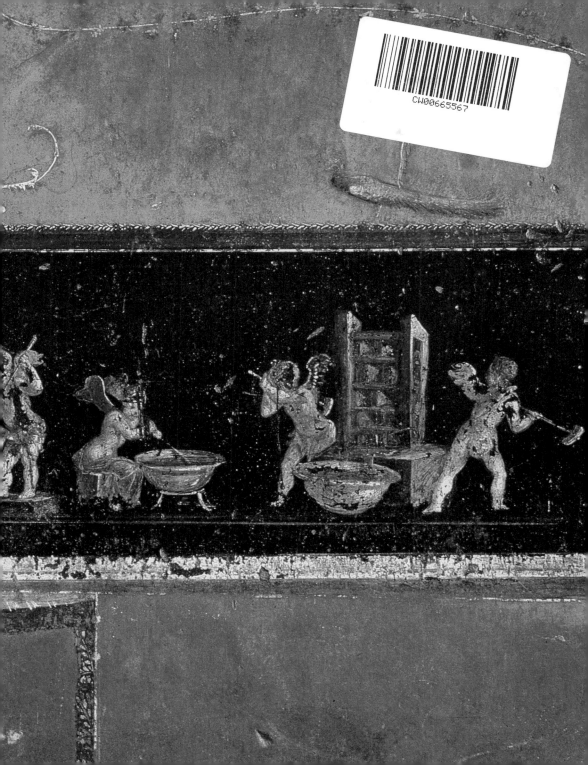

FABRIZIO PESANDO

POMPEII

THE ART OF LIVING

Cover
Fresco depicting the *Preparation of the Rite*, detail.
Pompeii, Villa of the Mysteries.

Flyleaf
Cupids making perfume.
Pompeii, House of the Vettii.

Production and publication
24 ORE Cultura srl

English translation
Paul Metcalfe for Scriptum, Rome

First edition June 2013
ISBN 978-88-6648-128-7

CONTENTS

FOREWORD

"What is there more holy, what is there more carefully fenced round with every description of religious respect, than the house of every individual citizen? Here are his altars, here are his hearths, here are his household gods: here all his sacred rites, all his religious ceremonies are preserved. This is the asylum of every one, so holy a spot that it is impious to drag any one from it."

(Cicero, *De Domo sua*, 109, Eng. trans. C.D. Yonge 1891)

An ancient writer and a number of extensively excavated archaeological sites constitute a constant point of reference for anyone wishing to understand how a Roman house was organized and what life was like inside it. The writer is Vitruvius, an architect in the reign of Caesar who built some important public works, including the basilica of Fanum Fortunae (Fano), but sought above all to give his profession the dignity of an artistic discipline by writing a treatise on architecture in the awareness that the Romans had equalled and in some cases even surpassed the great Greek masters. Compiled in late antiquity and constantly read and commented on as from the Renaissance, his work is not confined solely to technical rules of construction but, like all ancient writings, also includes digressions on the history of architecture and reflections on the function of a body of knowledge. It is within this framework that Vitruvius presents his indications for the construction of the *domus iusta*, the perfect house. Even though we have numerous other observations on the Roman house, from the antiquarian writings of Pliny and Varro to the bitter or ironic pictures of everyday life painted by Martial and Juvenal, we must always return to the architect for any

understanding of its structure and how it functioned. At the same time, however, it must be borne in mind that Vitruvius was not the author of a book for archaeologists and architects of the 3rd millennium but a cultured man of the 1st century BC writing for the members of a small oligarchy who often also handled public business in their homes, an oligarchy that was almost completely wiped out by civil war within a few decades. And then we have the extensively excavated archaeological sites miraculously preserved in the wake of one of the greatest natural catastrophes in history (like the Vesuvian cities of Pompeii and Herculaneum) or through gradual abandonment and oblivion (like Ostia). Each of these immensely important sites has, however, a specific history of its own that influenced its way of organizing the public spaces, places of worship and way of living.

We know that the period of Pompeii's greatest development coincided with the Samnite era and the first decades of the Roman colony, the period spanning the 2nd century BC and the first half of the 1st, characterized by the political and economic expansion of Rome and Italy throughout the Mediterranean: precisely the age that Vitruvius had in mind when writing his treatise. What we see in many Pompeian houses is therefore a sort of fossil formed in a specific moment and a specific society. A few kilometres away in the small town of Herculaneum, built almost entirely in the imperial age, many things are different and we are often disconcerted on entering its dwellings not to find the rooms that we believed to be so characteristic of the Roman house after visiting Pompeii. The world had changed in the space of a few decades, however, also as regards habitation, and the horizons of Vitruvius had practically vanished.

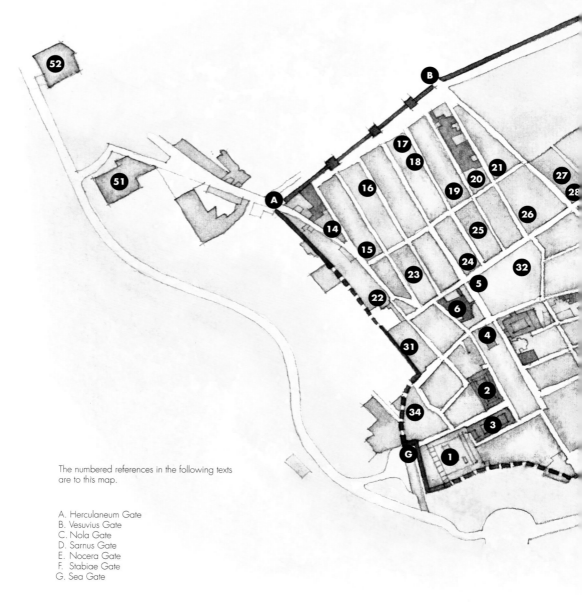

The numbered references in the following texts
are to this map.

A. Herculaneum Gate
B. Vesuvius Gate
C. Nola Gate
D. Sarnus Gate
E. Nocera Gate
F. Stabiae Gate
G. Sea Gate

1. Temple of Venus
2. Temple of Apollo
3. Basilica
4. Capitolium
5. Temple of Fortuna Augusta
6. Baths of the Forum
7. Temple of Minerva
8. Temple of Isis
9. Temple of Asclepius
10. Large Theatre
11. Odeion
12. Gladiatorial Barracks
13. Stabian Baths
14. House of the Surgeon
15. House of Sallust
16. House of the
Grand Duke of Tuscany
17. House of Meleager
18. House of the Centaur
19. House of the Labyrinth
20. House of the Vettii
21. House of the Gilded Cupids
22. House of the Golden Bracelet
23. House of Pansa
24. House of Zephyr and Flora
25. House of the Faun
26. House of the Scientists
27. House of Caecilius Iucundus

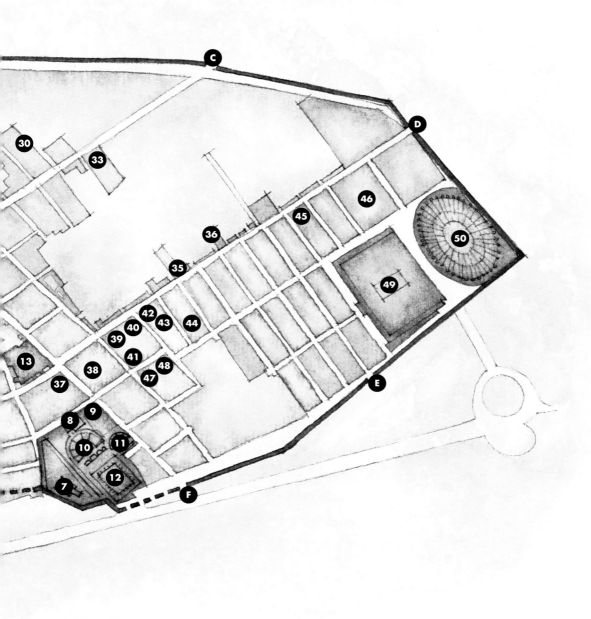

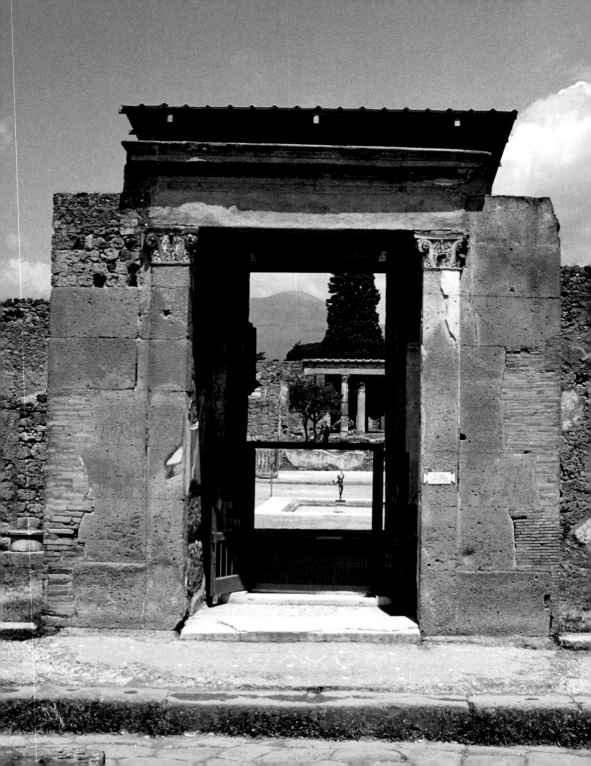

THROUGH
THE ANCIENT ROOMS

Standing on the Via dell'Abbondanza, nearly halfway between the areas of the Forum and the Amphitheatre, is a house regarded by architects and archaeologists as almost exemplary in terms of structure and decoration. We refer to the House of Trebius Valens (no. 36) (fig. 2), which caused a stir at the time of its discovery due to the large number of electoral inscriptions deftly painted on his façade. Very little of that façade remains today, as this stretch of the most famous street in Pompeii was hit by bombs dropped from Allied aircraft on 19 September 1943. Subsequent restorations fortunately made it possible to save the rest of the house and the decorations in its rooms. While it is considered exemplary, as stated, the trained eye will soon note that it was not built in the form visible today but was rather the result of a series of enlargements made to a small and very ancient dwelling constructed of large blocks of limestone. As from the 1st century BC, however, when it became the property of an important magistrate of the colony (the owner also of a statue base found in the vicinity of the garden), the house took on the "canonical" form that helps us to find our way through the ancient rooms. We have already mentioned the importance of the façade, which performed the function of making passers-by aware of the owner's status when the entrance was open, as it generally was from the early hours of the morning on. Long benches of masonry coated in plaster were sometimes found on either side of the entrance. While their

Page 8
1. House of the Faun,
entrance portal.

2. House of A. Trebius
Valens, plan indicating the
functions of the rooms.

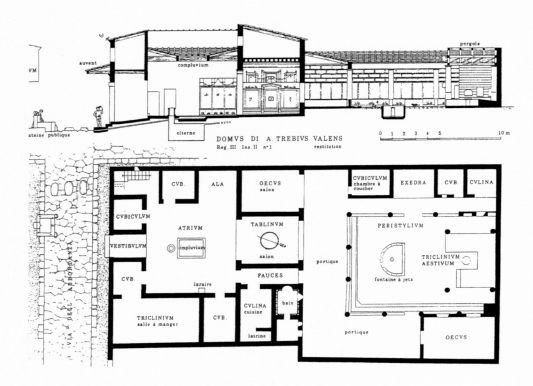

DOMVS DI A. TREBIVS VALENS
Reg. III Ins. II nº 1 restitution

function is not entirely clear, it is very often claimed that they served the *clientes* (relatives or dependents) waiting to be received by the master of the house. The presence of these seats before buildings of both high and medium status (exemplified respectively by the large House of Menander, no. 48, and the nearby House of the Ceii, no. 41) and their rather late dating supports the view that they were also used by waiting slaves with particular duties such as *lecticarii* (litter-bearers) or *muliones* (muleteers).

The open doorway served almost like a display window to make the interior visible. This was a custom inherited from the republican past of Rome, when an austere lifestyle was a prerequisite for being con-

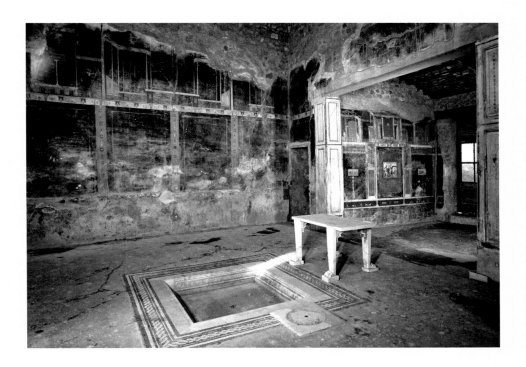

sidered a good citizen. It then turned, however, into a way of flaunting the luxurious decorations and furnishings in the heart of the house, a display sometimes made still more spectacular by the addition of jets of water from richly decorated fountains, like the one that gives the House of the Bull (no. 28) its name. The heart of the dwelling was the large central courtyard, known as a *cavaedium* or *atrium*, onto which all the most important rooms looked. Vitruvius lists the various types of atrium used in his day (Tuscan, Testudinate, Tetrasyle, Corinthian), the most common of which (like the one in the House of Trebius Valens) was the Tuscan, which was believed – and rightly so, as archaeological discoveries have shown – to have been invented

in Etruria and spread from there to Rome, then its colonies, and finally the allied cities, as in the case of Pompeii.

The atrium was not only an architectural space, however, but also the stage for a performance starring the master of the house, the *dominus*. For this reason, Vitruvius states that people of modest condition (*homines tenues*) had no need of houses with large atriums, as they did not have to receive visits but rather to pay them in accordance with their social obligations (fig. 3). Receiving light from an opening in the centre of the roof (the *compluvium*) – through which water was channelled into a pool in the middle of the space (the *impluvium*) and from there often into a cistern below – the atrium was so enormous in some cases as to accommodate hundreds of people at once. Cases of this type, studied in detail, are exemplified by two gigantic Pompeian mansions, the houses of the Silver Wedding (no. 29, fig. 4) and of Obellius Firmus (no. 33), where the huge beams of the *compluvium* were sup-ported by massive Corinthian columns of tuff nearly eight metres tall. This was the space crowded with *clientes*, announced by rank, degree of kinship and role as from the late republican era by the *nomenclator*, a particular slave who also performed the delicate task of prompting the master with all the information needed to display the requisite magnanimity, tolerance or severity. The true stage of the *dominus* was the room at the rear of the atrium, clearly visible from the entrance and often emphasized by slight elevation or particularly sophisticated decoration. This was the *tablinum*, a name for which different explanations were offered by the ancients themselves, who suggested a derivation from *tabula*, which could indicate the door of folding panels separating it from the atrium or the tablets of the domestic records stored inside. The latter interpretation is generally considered more plausible, as it is known that the house was also used for a series of proceedings within the sphere of private law, such as the celebration of weddings,

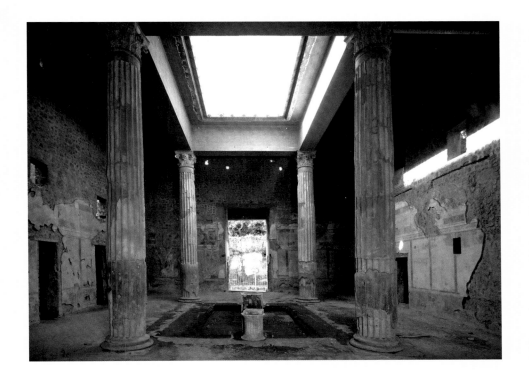

adoption procedures and the drawing up and public reading of wills. It is precisely by virtue of its function as the repository of domestic records that the *tablinum* was almost considered a sacred place. It can still be perceived as such in the most celebrated and imposing of Pompeian mansions, the House of the Faun (no. 25), built at the end of the 2nd century BC for the noble family of the Sadirii (*Satrii* in Latin), members of which were elected to the city's most important positions

during that period. The large room, set at a slightly higher level than the atrium, was decorated with a sophisticated floor of coloured limestone tiles in a pattern of perspective cubes, wholly identical to the one in the cella or inner chamber of the Temple of Apollo (no. 2) (fig. 5). The choice of decoration, made still more sophisticated by the First Style painting on the walls, was not fortuitous, as the bronze statuette of a dancing satyr found in front of the *tablinum* on the edge of the

5. Temple of Apollo, pavement with cubes of coloured limestones in perspective (*scutulatum*). This refined decoration was also used in the *tablinum* of the House of the Faun, imbuing it with a sacred atmosphere.

6. House of the Faun, drawing of the atrium. The base of the small statue of the dancing satyr (*skyrtos*) is visible.

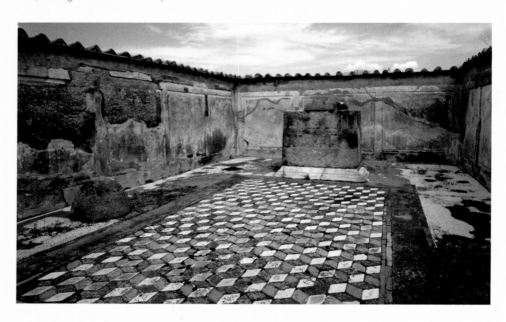

impluvium bears an inscription indicating its weight and demonstrating that it had been specially purchased on the antique market. A watercolour by Fausto Niccolini (fig. 6) shows us what the atrium looked like at the beginning of the 19th century, when the satyr – standing on a base of tuff and therefore clearly visible also from the street – must still have been erroneously placed in the centre of the *impluvium*. The companion of Dionysius, the divinity al-luded to also by other decorations pres-ent in the house (mosaics of theatrical masks, a coupling of a satyr and a nymph and a Bacchic triumph, fig. 7), was in fact probably regarded by the Sadirii/Satrii family as an ancestral and mythic ances-tor still reflected in their name. Traces of this descent were almost certainly to be found in family tales, something akin to the Roman *carmina convivalia*, verses recited at banquets in which families of

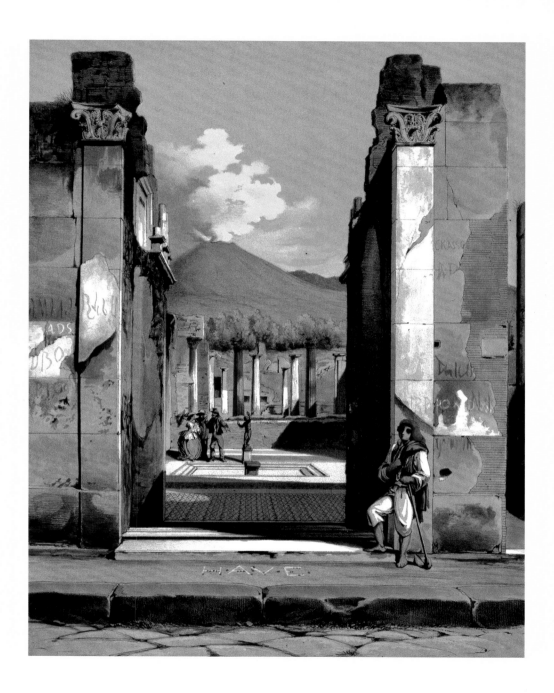

7. House of the Faun, mosaic
with *Theatrical Masks*.

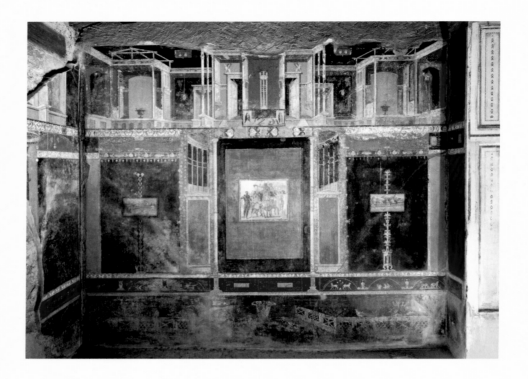

ancient nobility celebrated heroes from distant and ill-fated lands, mythological figures and even divinities in some cases as their founders. This function of the *tablinum* was preserved for a long time in Pompeii, even when the room was no longer accorded much importance elsewhere and sometimes eliminated to make way for more spacious and airy chambers for banqueting and entertainment. As we shall see, however, the weight of an age-old history made itself felt in the Vesuvian city until the moment of destruction. Halfway through the 1st century AD, the owner of the small but sophisticated House of M. Lucretius Fronto (no. 30) had the *tablinum* refurbished and decorated with the finest paintings in the entire house (fig. 8). As the heart of the house, the atrium provided access to a series of rooms devoted to specific uses. First of all the *cubicula* or bedrooms. These were small and often summarily decorated as they had to be dark and above all sheltered in both the

cold and the hot seasons. Deep recesses in the walls make it possible to reconstruct the original positions of the beds, which became increasingly large in the imperial age even though used by just one person. The large number of *cubicula* confirms that each room was used by a single member of the family even when there was sufficient space for a second pallet, generally occupied by a handmaiden or servant.

In the atrium house, the large chambers situated on either side of the entrance and beside the *tablinum* were used as the dining room (*triclinium*) or salon (*oecus*), in which both family and guests gathered. This aspect again shows the social function of the Roman house, which, unlike the Greek, constituted an authentic meeting place, in some cases also of a political nature. The agora was the focal point of public life in the Greek cities and the house remained a private place, with whole areas deliberately made inaccessible to outsiders (the women's quarters, the rooms for housework and the storage areas, generally located on the upper floor or around a second courtyard). With its doors wide open to the outside, strongboxes deliberately placed in the atrium to display wealth, the free circulation of inhabitants and entire sections used to receive guests and visitors, the Roman house was instead a little world projected towards the larger one outside. As Vitruvius wrote, "for the dignitaries who occupy important positions and must therefore place themselves at the service of the citizenry, it is necessary to build tall and regal vestibules, atriums and large peristyles […] as well as basilicas differing little from the magnificence of public works, as both public deliberations and private judgments and decisions very often take place in their homes." And the history of the late Roman republic shows that many of the key decisions for the collectivity as a whole were not taken in the Forum but during sumptuous banquets or between the sheets in bedrooms.

LIVING
IN THE GREEK STYLE

So far we have considered the area of the atrium, with its spaces inherited from a remote past and all the complex rituality we have seen characterizing its use. Behind this was the *peristyle* (fig. 10), a large area very often found in both aristocratic and medium-level houses. The word indicates an arcaded courtyard and is obviously of Greek origin. The peristyle did not in fact constitute an original element of the Roman house. Both the ancient sources and archaeological investigations show that its introduction did not take place until the 2nd century BC, when the Romans and their Italic allies had become better acquainted with the Greek world through numerous wars of conquest followed by intense trade and cultural contacts. The acknowledged superiority of recently conquered Greece

also had a substantial influence on the structure of the house, which constituted – as we have seen – the nucleus of Roman society as a whole, and altered the customs of the new rulers to no small degree. The peristyle was not in fact only a place for a pleasant walk to admire a beautiful garden but the place where the master of the house could withdraw with his *amici* from the activities connected with his role as *paterfamilias*. And this took place in the very spot once occupied by the *hortus* or *heredium*, the laboriously tended vegetable patch that played no negligible part in feeding the household. The construction of "airy peristyles" thus contributed to the definitive integration of the time for business (*negotium*) and the time for leisure (*otium*) in the domestic context. The size and decoration

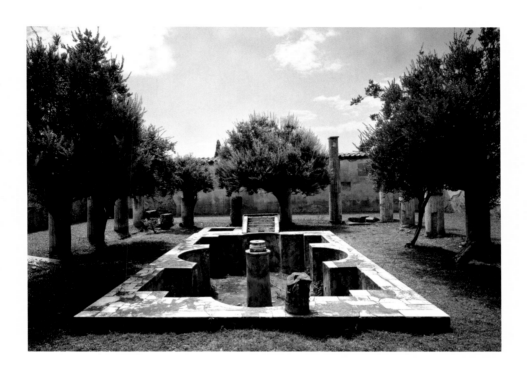

of the peristyle naturally varied in relation to the wealth of the *domus*. In the House of Trebius Valens (no. 36), where it is limited to three sides with columns of brick or masonry, a small fountain was placed in the central section and it was not until just before the eruption that a large triclinium-shaped structure was built against the rear wall for summer banquets in the shade of a pergola. Nothing like the imposing peristyles of the houses of the Faun (no. 25), Pansa (no. 23), the Coloured Capitals (no. 32), Meleager (no. 17, fig. 9) and the Cithara Player (no. 38), with the tens of Doric or Ionic columns of tuff framing a vast garden (*viridarium*) where ornamental and fruit

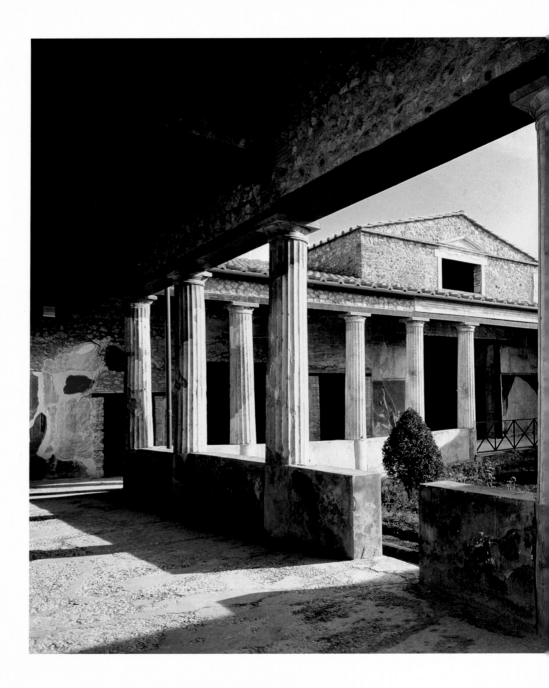

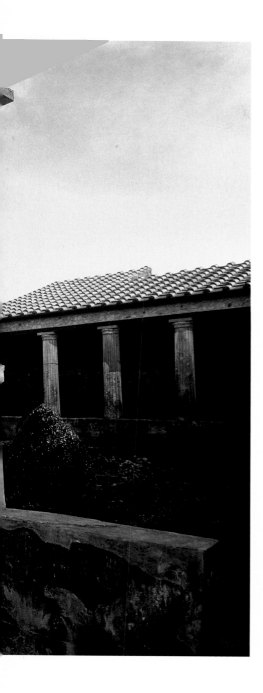

trees and authentic nymphaea delighted the residents and their guests.

It was obviously the most sumptuous rooms of the house that opened onto the peristyle. A series of chambers for reception, rest and recreation reflected the rhythms and patterns of domestic life: large spaces completely open on the porticoes (the *exedrae* or *alae*), banqueting halls (*triclini*) and salons (*oeci*) sometimes so vast as to be divided with rows of columns; and finally a series of *cubicula*, exposed either to the north and therefore used for rest during the torrid summer season, or to the south so as to be protected from the cold winds of winter. These were the rooms decorated with the most sophisticated paintings and mosaics, like the Corinthian *oecus* in the House of the Labyrinth (no. 19), its walls animated by one of the most daring architectural scenes in the Second Style discovered in the city (fig. 11), or the room in the House of the Ephebe (no. 43) with a floor of costly marble tiles arranged in an exceptionally skilful composition (fig. 12). Every

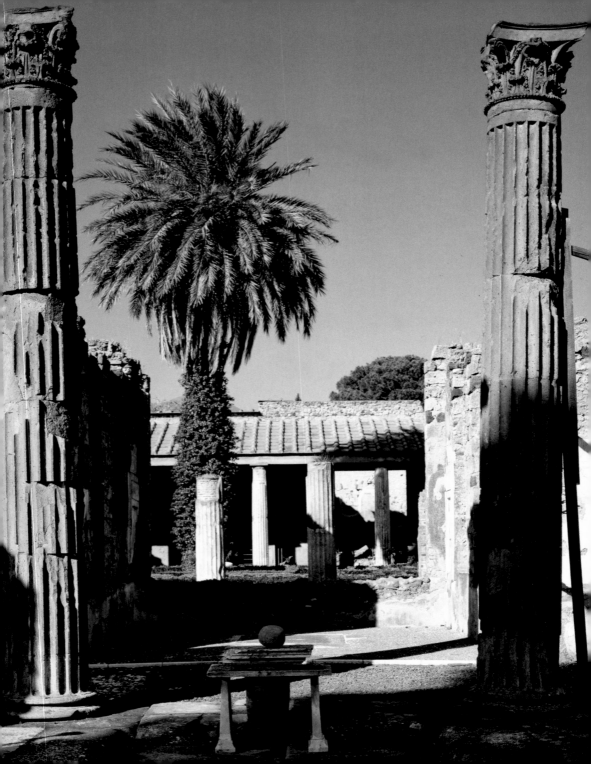

Following pages
12. House of the Ephebus,
pavement of the reception room.

room was required to transmit signals indicative of the values with which the family identified, and often, as we shall see, the vocabulary chosen was that of mythological images, whose interpretation could sometimes prove so complex as to give rise to authentic dissertations about their meaning or about which of the many Greek painters celebrated in writings on art first addressed the subject and on what particular occasion. The finishing touch of so much refinement was the addition of a small bath house. This was not an authentic rule, as is shown by the fact that Vitruvius makes only a brief mention of domestic bathrooms but instead attaches vital importance to the presence of a gallery to display original paintings bought on the antique market or a library, where the books had to be carefully stored so as to avoid damage from damp and moths. With the adoption of the system of heating beneath the floors and along the walls, it had in fact become very difficult for private citizens to install and maintain domestic baths. This is why only a few Pompeian houses had authentic bath houses, and nearly always on a fairly modest scale. A facility of this type is documented precisely in the House of Trebius Valens, which thus becomes still more exemplary in our eyes. The owner, who took possession of the house at the beginning of the 1st century BC, decided to eliminate one of the rooms beside the atrium and transform it into a small bath house. Divided into just two parts (antechamber and hot room), this was small and dark, however, certainly more similar to the ancient baths used by Scipio Africanus in his villa at Literno than the large and comfortable public baths newly renovated or built in Pompeii (the Stabian Baths and the Baths of the Forum). With the exception of some sumptuous residences like the houses of Menander (no. 48) (fig. 13), the Silver Wedding (no. 29) and the Cryptoporticus (no. 40), private baths thus became increasingly rare over the years to the point where in some cases they were not even rebuilt after the damage done by the earthquake of 62–3 AD. From that

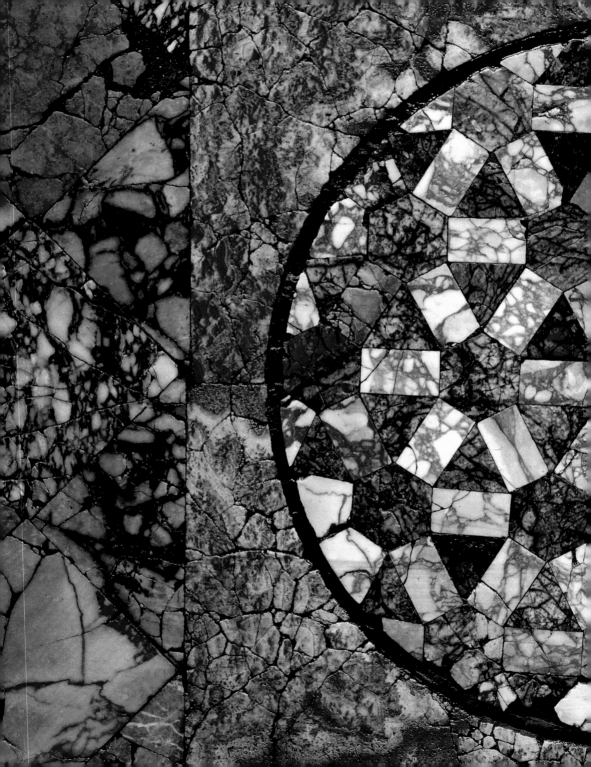

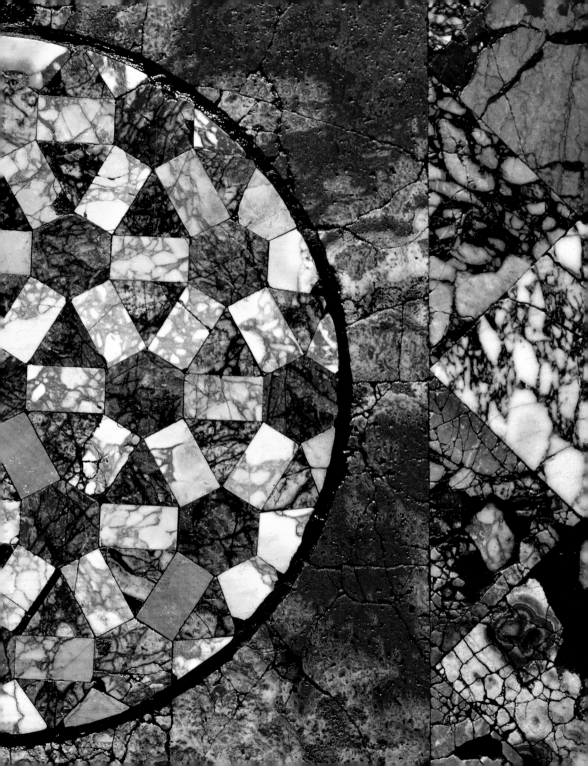

point until the time of the eruption, rich Pompeians preferred to use privately run establishments like the Suburban Baths, the Sarno Baths and the small baths in the great urban villa owned by Julia Felix (no. 46), where an inscription promised users the comfort of a public baths and the confidentiality of a private one.

So far we have spoken of luxurious houses owned by aristocrats or in any case by the wealthy. Vitruvius, who was well aware of the rigid social hierarchy of the world he lived in, pointed out, however, that there were many other people whose way of life and houses were very different indeed from those outlined above. It is only a compara-tively small number of the over six hundred houses brought to light in Pompeii that belong to the type with atrium and central *impluvium*. The many houses that we pass by without lingering too long were much simpler in architectural terms, organized around covered courtyards (*atrii testudina-ti*), and the interior decoration was nearly always confined to one or two rooms used for dining, receiving relatives and friends, and sleeping. But it was in these houses – characterized by noise, questionable hygiene and strong smells, where the smoke and fumes of the kitchen mixed with the pungent aromas of workshops – that most of Pompeii's inhabitants lived.

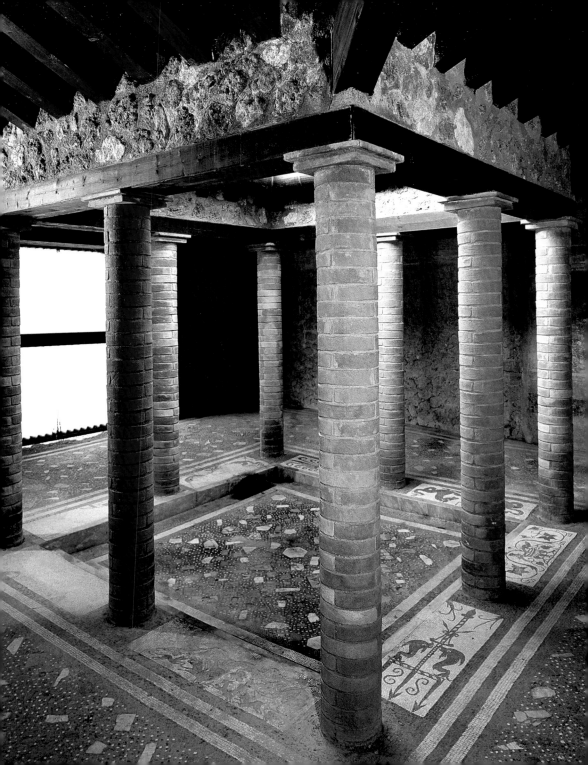

Furnishings

Those visiting the houses of Pompeii, while full of wonder and admiration, cannot fail to note how sparsely they are furnished. To eyes generally accustomed to a clutter of furniture and ornamental objects, the bare appearance of the rooms of a Roman house somehow suggest a minimalist setting, and there is some truth in this impression. As was indeed the case also in medieval times, Roman domestic furnishings were geared above all to functional requirements. The overall effect was, however, certainly not what we see today. The almost complete lack of furniture is in fact due to its destruction in the fires that repeatedly devastated the city and by the material with which the eruption of Vesuvius buried it, an impalpable mass of ash and lapilli that allowed the passage of air and thus caused all objects of organic origin to perish definitively. Plaster casts of strongboxes and furniture and even the preservation of jambs of carbonized wood (as in the House of Menander, no. 48) do provide some insight into domestic furnishing in some cases, but certainly not enough for us to reconstruct the variety of the objects present in the houses. It is a very different story, however, in nearby Herculaneum. This Vesuvian town was instead buried in a compact layer of volcanic mud that preserved the wood almost intact, so that it has sometimes emerged from the excavations practically unscathed, even without any trace of scorching. It is thus possible to see, albeit with the characteristic austerity of the furnishings of ancient houses, that there were various types of wooden fur-

15. Bronze brazier, from the House of Menander.
Naples, Museo Archeologico Nazionale.

Preceding page
14. Lid of medicine chest with Aesculapius and Hygea
depicted in silver, from Herculaneum. Naples, Museo
Archeologico Nazionale.

16. House of the Theatrical
Paintings, marble 'lion paw'
table base, which belonged
to P. Casca Longus, one of
Julius Caesar's assassins.

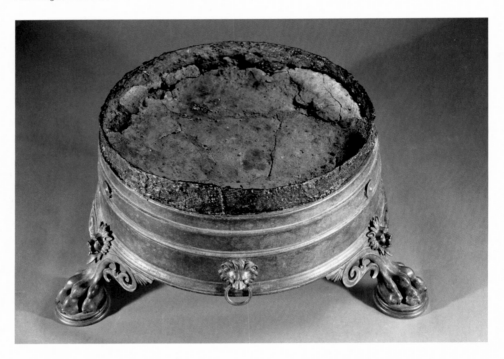

niture (fig. 14) including some sophisti-
cated items: beds with carved headboards,
inlaid cabinets, shrines for domestic wor-
ship, chests, tables, benches, chairs of dif-
ferent shapes and sizes, cradles and even
articles of extraordinary artistic merit, in-
cluding some wooden tripods covered in
ivory panels decorated with ritual scenes
recently discovered during the excavation
of the Villa of Papyruses.

Some furniture was in any case also spared
in Pompeii, and the little that survives is very
valuable because it consists of articles and
ornaments in marble and bronze (fig. 15).
Most of the items are tables of white lime-
stone or marble. One of great importance,

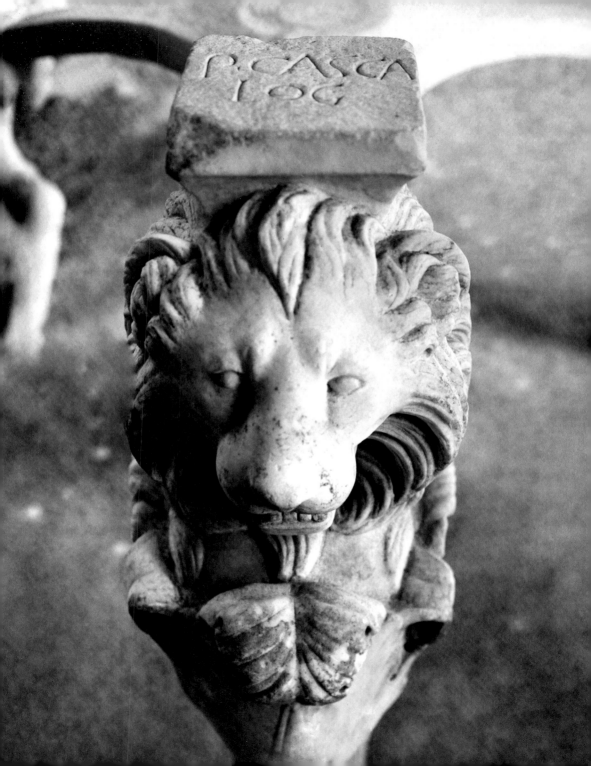

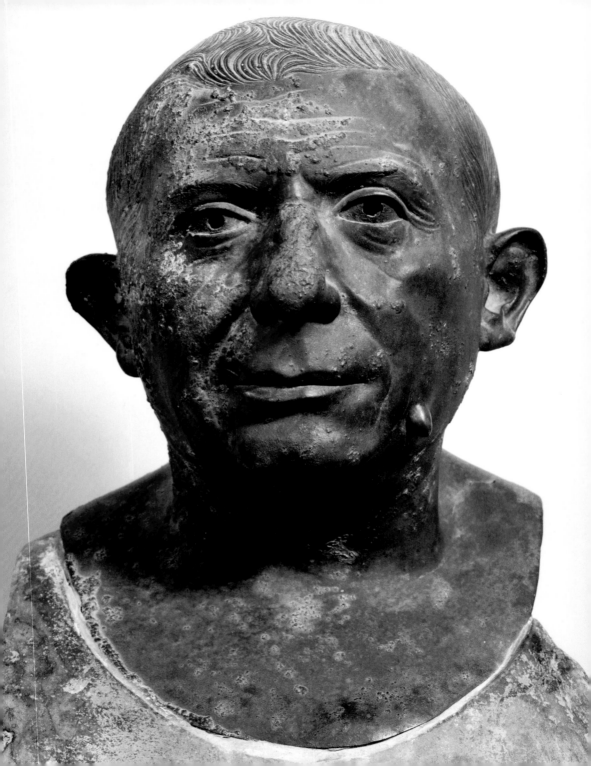

an elegant round table of Greek marble with three lion-shaped legs dating from the first half of the 1st century BC (fig. 16), stands out from the others not only for its exquisite craftsmanship. The most interesting aspect of this artefact is in fact the inscription carved into one of the legs, where we read the name of P. Casca Longus (no. 39), one of the assassins of Julius Caesar (supposedly the first to stab the dictator). The presence of this table in Pompeii can therefore only be explained as a purchase made after the conspirators' defeat at Philippi (42 BC) and the confiscation of their property. The sculptures, which are not in fact very numerous, were placed in the gardens above all and constituted the most sought-after and expensive form of domestic decoration. The works, nearly always in marble, are generally of mythological figures conjuring up the wild world outside the well-organized city: above all satyrs and maenads but also heroes like Hercules in solemn or mundane poses. There are instead few portraits. The custom of exhibiting the faces of ancestors in the atriums of houses was not in fact as common as many literary or cinematographic reconstructions would suggest. The right to exhibit portraits together with captions illustrating the deeds of illustrious ancestors was in fact a prerogative of Roman nobles and subject to a special law (the *ius imaginum*). It is therefore hardly surprising that Pompeii is practically devoid of this type of material apart from the odd bust of the *patronus* commissioned by a faithful freedman, as in the houses of Cornelius Rufus (no. 37) and Caecilius Iucundus (no. 27, fig. 17).

DOMESTIC
PIETY

What is there more sacred than the home of each citizen? The question Cicero addressed to the priests of Rome introduces another aspect of the Roman house and one far removed from present-day customs and habits: the house was also a place of worship with its master as priest. Every important event in the lives of Romans was in fact subjected to rigid rules and rituals that often appear superstitious to modern eyes: sacrifices, the observation and interpretation of signs supposedly inspired by divinities or higher beings, and the imposition of particular forms of dress, hairstyle or make-up.

This is why the signs of religion are always recognizable in all dwellings, including the most modest and even shops. The most evident manifestation is the presence of a special room devoted to the domestic worship of divinities called upon to protect the family through direct intercession. This *sacrarium* was nearly always located next to the most important room in the home (the *tablinum* or one of the *oeci* looking onto the peristyle) and contained a small altar for offerings. The most sophisticated *sacrarium* known in Pompeii is the one in the House of the Iliac Chapel (no. 40, fig. 19), where the ceiling was decorated with mythological scenes alluding to immortality (Selene and Endymion, the abduction of Ganymede) and the upper section of the wall with the combat of Achilles and Hector, the most celebrated episode in the Trojan War. The presence of a series of alabaster doves, probably placed on the altar, indicates that it was devoted to the worship of

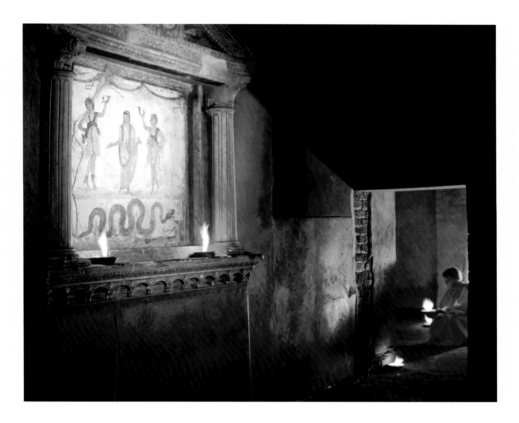

Venus, to whom those birds were sacred. It is possible to suggest that the family inhabiting the house claimed some descent from the goddess or from one of the Trojan families that constituted one of the original ethnic nuclei of the Roman people.

More common were the shrines located in atriums or kitchens and devoted to the Lares (fig. 18), the divinities of the domestic hearth, which were originally placed precisely in that area of the house. The Lares were seen as the spirits of the dead called

upon to protect their own domestic space and the area surrounding it. There was an authentic proliferation of the cults of the Lares, known as *vicinales* if they covered the families resident in the neighbouring houses or *compitales* if their sphere extended to all those living in the vicinity of a major crossroads (*compitum*).

Pompeii is an extraordinary source of knowledge for all these religious manifestations. In addition to the altars of *compitales* to be seen at practically all the main crossroads and the domestic *lararia*, recent investigations have revealed the existence of small niches cut into the outside of the entrance doorposts for offerings (especially coins) to the *Lares vicinales* on the day a bride entered her new home. The precision of the new methodologies of excavation and the focusing of attention on even the simplest manifestations of everyday life have also led to the discovery of small caches of votive offerings in the gardens of the houses consisting of a few objects and probably first fruits or flowers. It is possible that these were connected with the cycle of seasonal renewal and the cult of the dead, which the Romans celebrated in May, the month that announced the arrival of the season of harvests and abundance. The Penates, domestic divinities generally associated with the cult of the Lares, were called upon to protect the family stores. Further signs of day-to-day religious practice and the associated rituals include votive pits in the foundations of the walls of houses or beneath the main entrance containing remains of meals and tools as well as numerous niches in the walls, where lamps were presumably lit and garlands of flowers placed for the many holidays of the Roman calendar. It can be seen in some cases that new niches took the place of older ones filled in with cement and plastered over. This may indicate a change of ownership or a superstitious attempt to dispel hostile shadows from the past.

A STEP
BACK

Like Rome, Pompeii was not built in a day. In retracing the history of the city, we have seen that periods of great vitality alternated with periods of crisis all through the seven centuries between the time of its foundation (the end of the 7th century BC) and the eruption of Vesuvius (79 AD). Perhaps the most serious of these crises probably coincided with arrival of the Samnites in the 5th century BC, which involved almost complete depopulation of the settlement followed by slow recovery after the peace agreement made with the Romans in 308 BC. It is only from that point on that the numerous stratigraphic excavations carried out in the last decade have been able to document the existence of different types of houses. It has also been possible to establish that some of these were preserved more or less intact until 79 AD, whereas others were destroyed and buried under a layer of levelling during the radical rebuilding that began in much of the city halfway through the 2nd century BC. Until then, Pompeii was not completely occupied by houses as it appears today, and in many cases an entire block could consist of just a few buildings. The sites chosen for these were the best: near a major crossroads or on one of the small natural hills caused by the numerous eruptions of the prehistoric era. Between the beginning of the 3rd century BC and halfway through the next, the broad variety of types of housing reflects the social organization of a longstanding and rigidly structured community. For example, the houses of Zephyr and

Flora (no. 24), the Scientists (no. 26) and the Surgeon (no. 14) were built with their severe façades of limestone blocks on the largest plots in their blocks during the 3rd century BC. Recent studies have shown that the three houses are identical in terms of proportions and layout with a Tuscan atrium and a *tablinum* in line with the entrance and opening onto a small *hortus* at the back. This homogeneity evidently derives from the application of a model that unquestionably reached the small town of Pompeii just a few years earlier: the atrium house used since the archaic era by the Etruscan and Roman upper classes and spread by the latter through the numerous colonies founded in the 4th and early 3rd century BC in Latium, the inner Apennines and Campania. It is therefore hardly surprising that the Pompeian aristocrats should also have chosen this type for their own places of residence. The atrium house was not, however, the only type to be used by the Pompeian elite during the 3rd century BC. A house discovered beneath the late-Samnite structure of the House of the Centaur (no. 18) is in fact very different in layout with a small covered courtyard (testudinate atrium) onto which just a few rooms open, some of which being sumptuously decorated. The rooms display rigorous specialization in terms of use, probably in relation to the roles performed by the various members of the family. It has been possible to identify a room for domestic work used by the women, the *tablinum* reserved for the *pater familias* or master of the house, and at least two residential chambers used as communal areas and for receiving guests.

Towards the end of the 3rd century BC, even for houses of medium level like the one discovered beneath the late-Samnite structure of the House of the Grand Duke of Tuscany (no. 16), use began to be made of the model of a *domus* with atrium, *tablinum* and *hortus*,

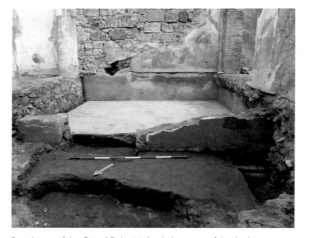

Proto-house of the Grand Duke Michael, the *oecus* of the third-century house was buried during the construction of the late Republican one.

which had thus evidently been chosen as best suited to the requirements of the emerging classes. From then on, there is no documentation of houses with a different, simpler layout in smarter districts of the city like Regio VI. The House of the Centaur, buried halfway through the 2nd century BC beneath a layer of infill about one metre thick, was itself rebuilt in the form of an atrium house with a large *impluvium* of tuff partly overlapping the sophisticated mosaic floor of the ancient *tablinum*. It is only in a few rare cases, like the House of Julius Polybius (no. 35), that the remains of an earlier house with no atrium survived enlargement and renovation. Generally speaking, houses of this type were for families of modest origin resident in areas some way from the city centre.

House of Julius Polybius, covered atrium (testudinate).

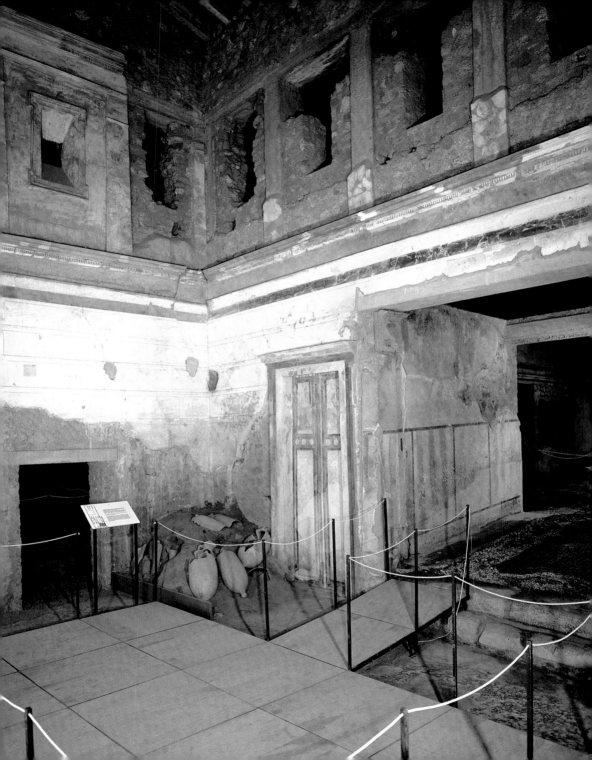

VILLAGES,
VILLAS AND FARMS

The large and small houses (*domus* and *domunculae*), the shops with their cramped mezzanines (*tabernae cum pergulis*) and the rented apartments reached by narrow staircases directly on the street (*cenacula*) did not exhaust the possible forms of habitation in a Roman city. The vast territory outside the walls, planned and divided into a system of roads, lanes, fields and properties, reflected the organization of the city with its differences and inequalities in another way. There were *vici* and *pagi*, agglomerates with a certain degree of independence administered by magistrates of inferior rank to those of the city (*magistri vici et pagi*) and providing facilities required by those living in the surrounding countryside, such as workshops and shops for the production and sale of specific products, places of entertainment, and the services of physicians, vets and herbalists. Something similar in terms of structure and function to the small towns built on the Pontine Marshes in connection with their large-scale draining and reclamation.

There were at least three agglomerates of this type in the surroundings of Pompeii. Practically nothing is known of one, the *Pagus Felix Augustus Suburbanus*, apart from the names of some magistrates. Founded by P. Cornelius Sulla, it was probably reorganized during the principate of Augustus and must have been located towards the slopes of Vesuvius in an area of villas and farms. More information is available on the settlements situated on the sea and at the

mouth of the Sarno river, and it is above all in the latter that buildings of a type not documented in the city at the time of the eruption have been discovered. One of these, known as the Building of the Triclinium in Moregine and undergoing renovation in 79 AD, housed a college used for meetings and banquets and has yielded some splendid wall paintings (figs. 20-21). Another two were large tenements with shops and taverns (*cauponae*) on the ground floor and internal staircases and large balconies providing access to the apartments on the upper floors. While the fact that the excavations were immediately covered over has prevented any further understanding, this scanty information is sufficient to suggest a structure resembling the *insulae* of Ostia, whose structure helped inspire the architecture of the large tenement-style public housing built in Rome in the 1920s and '30s. The roads running through cultivated fields and vineyards towards Vesuvius or following the course of the Sarno river in the direction of Nocera intersected with

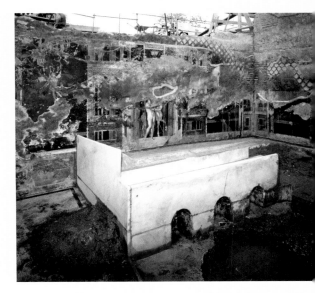

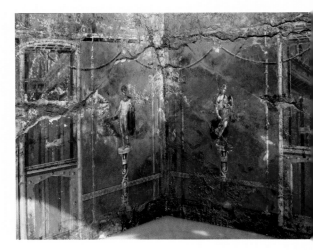

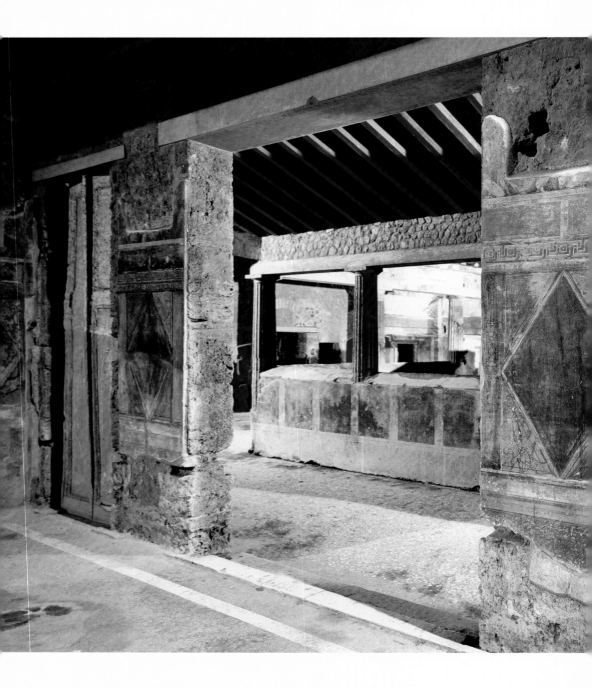

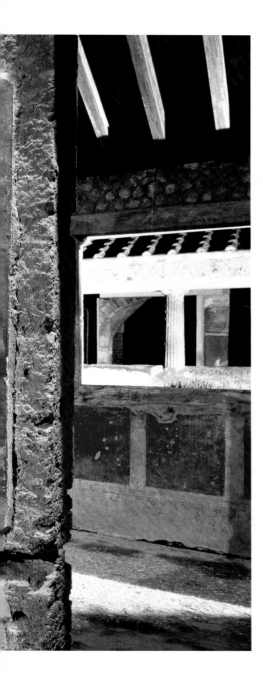

lanes leading to farms and villas, includ-
ing some of the best-known and most cel-
ebrated edifices of Vesuvian archaeology.
The Villa of the Mysteries (n. 52) and the
Villa of Diomedes (no. 51), both situated
in the northern suburbs of Pompeii, and the
perhaps imperially owned Villa Poppaea or
Oplontis in present-day Torre Annunziata
are names that immediately conjure up im-
ages of private luxury at a level unparalleled
until the Renaissance. As regards the origin
of the villa as an architectural model, Vit-
ruvius seems to suggest that it was nothing
other than a house with peristyle to which
an atrium was added, thus inverting the se-
quence of sectors. In the case of the Villa
of the Mysteries, the road did in fact end
at a large entrance providing access first to
a porticoed courtyard and only later to a
traditional Tuscan atrium (fig. 22).

The question is, however, more complex.
Underlying the spread of the aristocratic
villa are the dynastic palaces of Hellenistic
Greece, like those brought to light by the
excavations of Aigai (Vergina) and Pella,

capitals of Macedonia, where peristyles and richly decorated halls follow one another to multiply the spaces devoted to the wielding of power and the life of a vast court. It was first-hand knowledge of this world, which deepened increasingly with expansion into the East, that influenced the taste of the Roman and Italic nobles, who wished to imitate the lifestyle of the vanquished. It is no coincidence that many leading figures in the political life of the late Roman republic are remembered as the owners of splendid villas of evidently Greek style in the area of the Bay of Naples, including Sulla at Cumae, Marius at Misenus, Caesar at Baiae, Cicero at Cumae and Pompeii, Vedius Pollio at Pausylipon, Appius Claudius Pulcher and Calpurnius Piso at Herculaneum, to give just a few examples.

The primary characteristic of the villa, in which the long periods of political inactivity were spent, is therefore the multiplication of spaces, as in the Hellenistic palaces, with the addition of other areas to the canonical central nucleus with its courtyards.

The peristyle and atrium of the Villa of the Mysteries are thus combined with a small atrium providing access to a baths, *cubiculum* and hall, and with a large portico onto which further *cubicula* and halls opened, the more important of which decorated with a series of particularly sophisticated paintings. It is known that these areas were sometimes given exotic names alluding to the Greek world where their noble Roman owners had often received their cultural education. For example, Cicero called the peristyles of his villa at Tusculum the "Academy" and the "Lyceum" after the places in Athens that housed the most important schools of philosophy, founded respectively by Plato and Aristotle. The view also helped to make stays there still more pleasant. According to the geographer Strabo, a single huge conurbation of towns and villas extended uninterruptedly along the whole of the Neapolitan shoreline during the reign of Augustus. The most coveted sites were those overlooking the Bay of Naples, which in Pompeii and especially Herculaneum af-

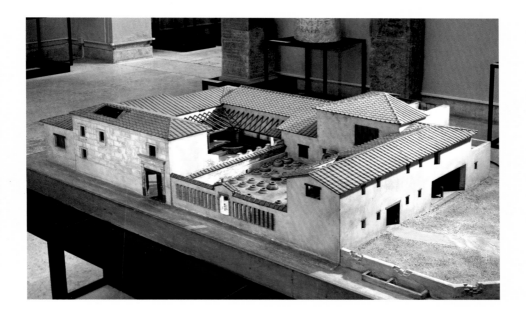

forded views stretching from the headland
of Misenus to Punta Campanella with the
islands of Ischia and Capri in the back-
ground. It is not difficult to imagine that
the view from one such portico, looking out
over a storm-tossed sea, provided Lucretius
with the inspiration to write: "'Tis sweet,
when, down the mighty main, the winds /
Roll up its waste of waters, from the land /
To watch another's labouring anguish far, /

Not that we joyously delight that man /
Should thus be smitten, but because 'tis
sweet / To mark what evils we ourselves be
spared" (*De rerum nature*, 2, 1–4). These
verses certainly caught the imagination of
the citizen of Pompeii who had them in-
scribed a few decades later on the painted
wall of a house looking out from the shore.
The villas, even the largest and most luxu-
rious, were almost never intended solely

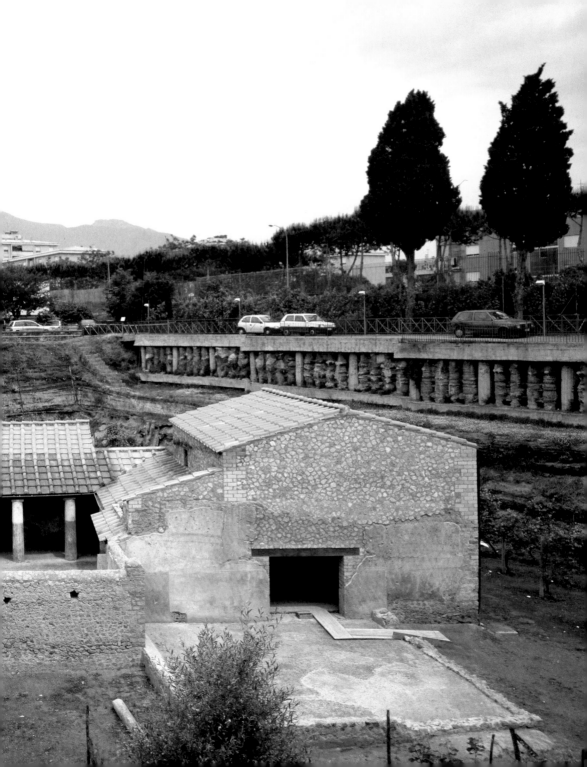

for pleasure, however. Surrounded as they were by vast expanses of land where intensive crops such as vines had been introduced, they always had a section of greater or lesser size devoted to production. This *pars rustica* covered over half the total area of the residence in the best-known case, the Villa Pisanella at Boscoreale (fig. 23). It was also very large in the Villa of the Mysteries, where the partial evidence of excavations suggests that it included at least one vast chamber occupied entirely by a millstone and a huge winepress (*torcularium*) as well as a series of rooms on different levels serving as stalls and quarters for slaves. In different architectural forms, the Roman villa was something like an American plantation before the abolition of slavery: a peaceful haven for the happy few exploiting the suffering of many. And special passageways identified by a simple zigzag pattern were also created for servants so as to avoid contact between the two worlds.

In addition to large villas, the Pompeian countryside was densely occupied by modest farms closely resembling those described a century earlier by Cato the Censor in his treatise *De agri cultura*. While the permanent occupation of agricultural areas had a long history, as shown by frequent discoveries of potsherds dating back to the pre-Roman era on sites subjected to archaeological excavation, it became particularly widespread with the founding of the colony in 80 BC, when land had to be allotted to the veterans of Sulla's army. The properties of the Pompeian rebels were thus expropriated and their houses destroyed. Evidence of this phenomenon is also provided by the Villa of the Mysteries, where a small fragment of a floor of the 2nd century BC, unquestionably belonging to a construction razed to the foundations when the property changed hands, is still visible in the eastern portico of the peristyle. The brutality with which the seizures were executed, signs of which have been identified also in other cases, caused discontent among the Pompeians, who were indeed suspected, shortly after the founding of

the colony, of lending support to the Cati-line conspiracy to overthrow the oligarchy. On one small farm, for example, two large sphinxes of tuff, almost certainly stripped from the ancient monumental tomb of its former Samnite owners in order to wipe out all trace of their memory, were defiled by use as guard stones.

These small farms, which failed to attract-ed the interest of archaeologists during the golden age of Pompeian excavations due to their architectural and decorative modesty, are better known today due to the discov-ery of the Villa Regina at Boscoreale to-wards the end of the last century (fig. 24). Constructed during the reign of Sulla and renovated about halfway through the 1st century AD, the farm was organized around a courtyard where eighteen large contain-ers of terracotta closed with lids and ca-pable to holding some ten thousand litres of wine were embedded in the earth. The living quarters were very simple and deco-rated with summarily executed paintings, most of the space being occupied by the *torcularium*, the barn and the stalls.

URBAN
VILLAS

In one of the notices painted at the time of the siege undertaken by Sulla in 90 BC in order to indicate the points where the beleaguered inhabitants were to gather in defence of the walls, it is stated that the soldiers under the command of Vibius Sexembrius were to concentrate at the houses of Maius Castricius and Mara Spurius. This is very interesting as it shows that even before that date some wealthy Pompeian families had chosen to build houses straddling the city walls so as to enjoy a view of the Bay of Naples and the Sarno valley. Some recent studies have also identified the location of these residences, which constituted the original nucleus of the great urban villas of Aulus Umbricius Scaurus (no. 34) and Marcus Fabius Rufus (no. 31). The term "urban villa" was coined in modern times to describe a type of urban residence re-

sembling the large suburban villas in many respects, from the choice of location to the inclusion of authentic miniature parks. The house of Marcus Fabius Rufus, which used the western shoulder of the ancient walls as a foundation (fig. 26), is a perfect combination of *domus* and villa. On entering from a lane in the vicinity of the Forum, one had the impression of being inside a large Tuscan atrium with mosaic floor and marble *impluvium*. This was only an impression, however, because there was no *tablinum* or other important room opening onto that atrium. As a result of radical renovation about halfway through the 1st century AD, it had been transformed into a gigantic vestibule through which members of the family, *clientes* and guests had to pass in order to reach an initial residential area made up of a salon looking onto a garden and another

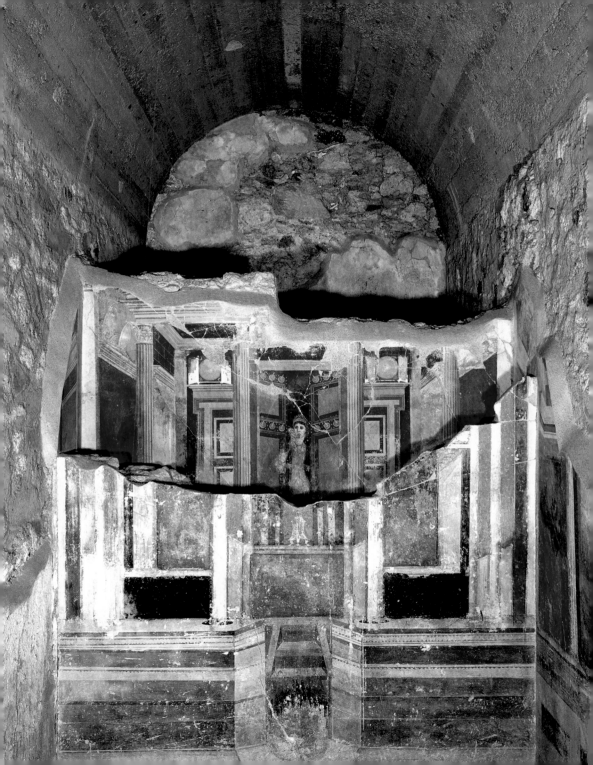

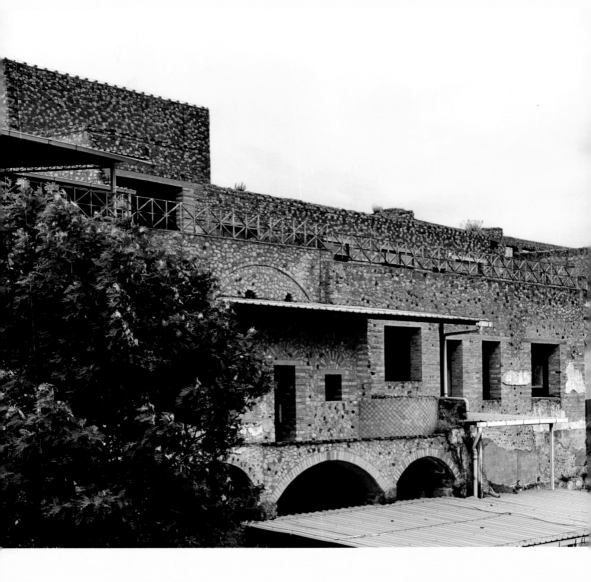

26. Urban villa of M. Fabius Rufus, view from the walls.

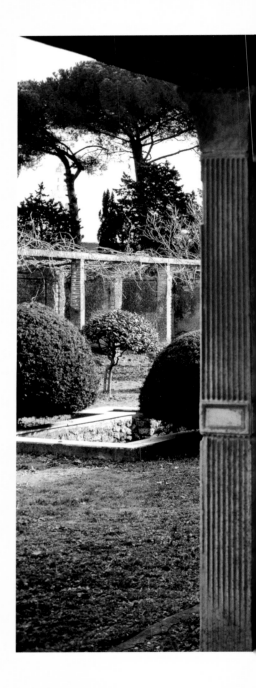

room of colossal proportions with large windows where the owner sought to reproduce the sophisticated *oecus Cyzicenus* described by Vitruvius in his treatise. The residential area continued with a panoramic terrace overlooking the sea and another two floors reproducing the structure of the basement levels, a layout developed some time before in the aristocratic Roman *domus* and in the seaside villas scattered along the gulf. The architectural focal point of the entire residence was a two-storey apsidal room with windows in the middle of the façade looking out to sea. It was here that the most precious and sophisticated decorations were concentrated, like the floor of coloured marble torn up by ancient plunderers and the Fourth Style decoration with paintings of mythological subjects on a black background. Standing out among the many rooms devoted to rest or convivial meetings is a bedroom that presents an extraordinary example of scholarly restoration carried out in ancient times. There were in fact two paintings on the rear wall, one on top of the other and separated

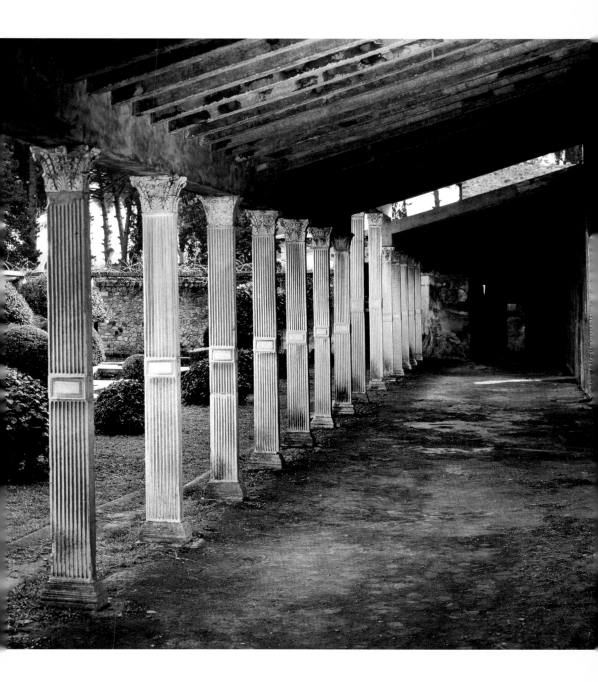

by a narrow interstice. The earlier work, dating from halfway through the 1st century BC, shows a complex religious edifice with a glimpse of the *Venus Fisica Pompeiana* through a half-open door. This is clearly a reference to the city's great sanctuary dedicated to Venus, which had already undergone renovation at the time when the room was decorated. It was then completely redecorated in the imperial age but maintaining the same subject. Executed in a crude style and far removed from the sophistication of the earlier work, the Venus of Pompeii thus continued to look out from her temple and protect the inhabitants of the house (fig. 25). The urban villas differed from one another as a result of the freedom enjoyed by the architect in the planning phase, which made it possible to introduce elements typical of the Roman villa with park (*hortus*) or the imperial residences at Baiae. The only common feature was a desire to arouse wonder in visitors and guests. A great park thus surrounded the three sections making up the *Praedia* of Julia Felix (no. 46), which occupied an entire block in the vicinity of the Amphitheatre. These comprised a modest *domus*, the remains of an ancient construction that survived the work undertaken about halfway through the 1st century AD; a garden with a series of salons looking onto a portico with marble columns of exquisite workmanship (fig. 27); and a huge baths capable of competing in terms of the sophistication and quality of its facilities with the public baths found at various points in the city. The many rooms in the villa included a particularly elaborate summer *triclinium* looking onto the centre of the portico in the garden. The banqueting couch of masonry with a marble facing surrounded by a narrow channel of running water was animated by a niche with a waterfall fed by two pipes from tanks installed above the service corridor, a system employed in the very same period for the triclinium-nymphaeum of Nero's *Domus Aurea* or Golden House in Rome.

Some more modest complexes also present elements of sophistication and innovation. In the House of Octavius Quartio (no. 45), as in the far more sumptuous House of Fa-

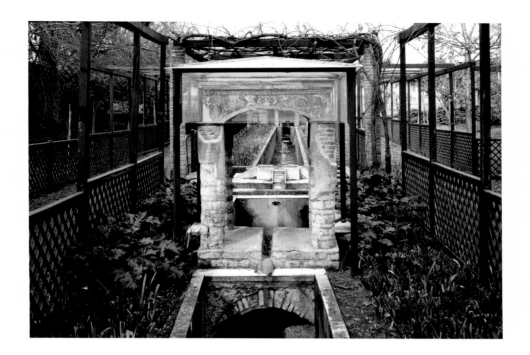

bius Rufus, it was decided to eliminate the *tablinum*, in this case certainly due to the lack of sufficient space for the creation of the large banqueting hall (*cenatio*) that came into fashion under Nero. The "great hall" can instead be identified as the huge room decorated with a painted frieze – an authentic rarity for the time – of the Trojan saga. The scenes feature both divinities (Hercules against Laomedon) and heroes (the funeral games in honour of Patroclus and Priam at the tent of Achilles), all complete with captions in Latin and probably serving as stimuli for learned discussions about the myths depicted. The real originality of the house unquestionably lies, however in the two artificial streams (*euripi*) running through the large garden (fig. 28) protected by pergolas and animated by cascades and fountains. The concentration of paintings of a religious character in the most important bedroom of the house, including a depiction of a priest of Isis, suggests that they did not perform a solely ornamental function but also helped to conjure up the Egyptian landscape over which the goddess reigned supreme.

THE HOUSE
AS A SEQUENCE OF IMAGES

The rich Pompeian houses presented an uninterrupted sequence of images and colours at the time of the city's destruction. This was nothing new, as the practice of covering walls with painted plaster was of ancient origin and had already found its earliest applications in Pompeii in the imposing houses of the 2nd century BC, like those of the Faun (no. 25) and Sallust (no. 15), which still retained much of their First Style decoration in 79 AD. As from the first half of the 1st century BC, the colours were accompanied by increasingly numerous depictions of mythical and historical characters, allegorical and symbolic objects, and finally reproductions or citations of celebrated easel paintings, nearly all works by Greek masters and often taken to Rome as booty during the wars of expansion in the East (fig. 29) or ruthlessly pillaged from hallowed places, as during the reign of Nero.

By virtue of their objective aesthetic and symbolic value, the most extraordinary images to modern eyes are those contained in *megalographiae*, a pictorial genre that became widespread in the late-republican age and owes its renown above all to the discovery of the Hall of Mysteries in the villa of the same name (no. 52, fig. 30). According to the ancient sources, a *megalographia* was a painting characterized by large-sized figures illustrating mythological or lofty subjects, originally produced in Greece for the powerful and cultured clientele of the Hellenistic dynasts and their dignitaries as well as wealthy landowners, merchants and businessmen.

Women play the leading role in the hall of the Villa of the Mysteries, where they

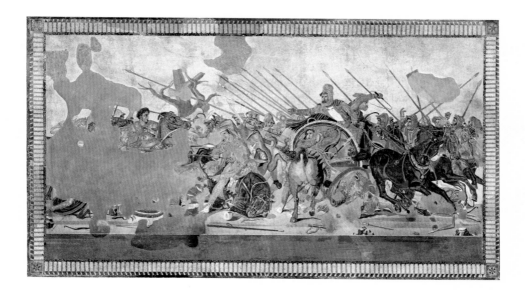

appear all the way through the narrative sequence. The mirror-like representation of an enthroned lady at the beginning of the long walls (perhaps the same woman shown at different moments) is followed by other female figures engaged in the performance of a series of actions imbued with great symbolic significance such as combing the hair in the presence of a pair of cupids, preparation of a ritual meal, an offering of sacramental cake made by a young pregnant woman. These all converge on the centre of the rear wall of bottom, which is dominated by a couple made up of Dionysius and a female figure identified as Aphrodite-Ariadne (fig. 31). The divinities are flanked by mythological figures closely connected with the Bacchic sphere (satyrs, sileni, panes and maenads) or figures caught up in the frenzy (*enthousiasmós*) that takes possession of the god's worshippers (scenes of wine drinking, dancing, ritual lashing and opening of the mystical basket, fig. 32). Myth and ritual are perfectly combined in

30. Villa of the Mysteries,
reception room.

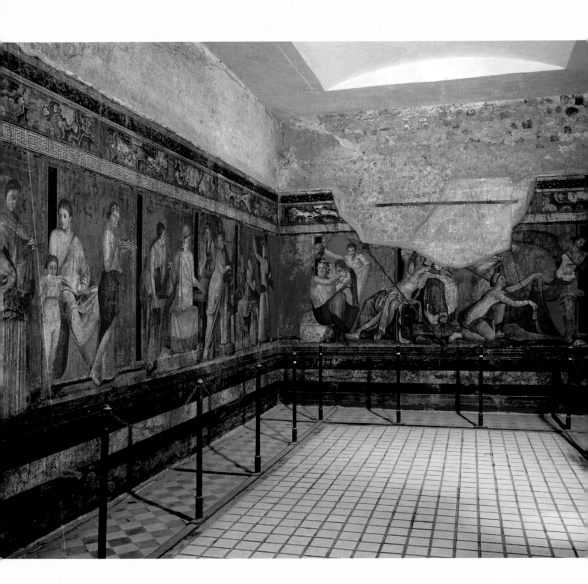

Pages 66-69
31. Villa of the Mysteries, far wall with fresco
depicting *Dionysus and Aphrodite-Ariadne*.
32. Villa of the Mysteries, reception room
with fresco depicting the *Ritual Dance and the
Uncovering of the Ceremonial Basket.*

Pages 70-73
33. Villa of the Mysteries, fresco
depicting the *Preparation of the Rite*.
34. House of Paquius Proculus,
Tuscan atrium with mosaic decoration.

painting of a clearly religious spirit. The couple of Dionysius and Ariadne was in fact the guarantee of perfect harmony between the human sphere and the divine, a theme particularly cherished by the Roman and Italic elite of the 2nd century BC. The subject was then laden with further symbolic references to prosperity in Pompeii at the time of the founding of Sulla's colony, when the very name of Pompeii was associated with that of Venus or Aphrodite, the divine personification of Ariadne, the human spouse of Dionysius.

While embedded in this broad sphere of Dionysian religion, the fresco in the Villa of the Mysteries remains an absolutely unique work and its subject matter has therefore given rise to countless interpretations. Amongst the many possible explanations, it should not be forgotten that the central role assigned to the divine couple represents the culmination of the representation of a sacred wedding focused on the preparatory phases and the union of a young woman and Dionysius: something

that was mystical and secret but must have been comprehensible, at least in its essentials, to a cultured and observant viewer. It may have been intended as an allusion to the collective propitiatory rite celebrated every year in Athens with the union of Dionysius and the wife of the archon basileus, which took place, according to Aristotle, in a building situated in the city's archaic agora. In any case, leaving aside the many possible interpretations, what is most striking about the series of paintings is the sensitivity shown by the painter in presenting the various phases in the life of a woman solely through depiction of the female body, unfledged in its nakedness and adolescent turmoil, graceful in preparation for the sexual union, mature in the swelling of pregnancy, shapely in womanly serenity (fig. 33).

The decorations of all the rooms of the Pompeian houses contain more or less evident allusions to the beliefs, values and culture of those who lived there. Sometimes they are elementary, like the call for

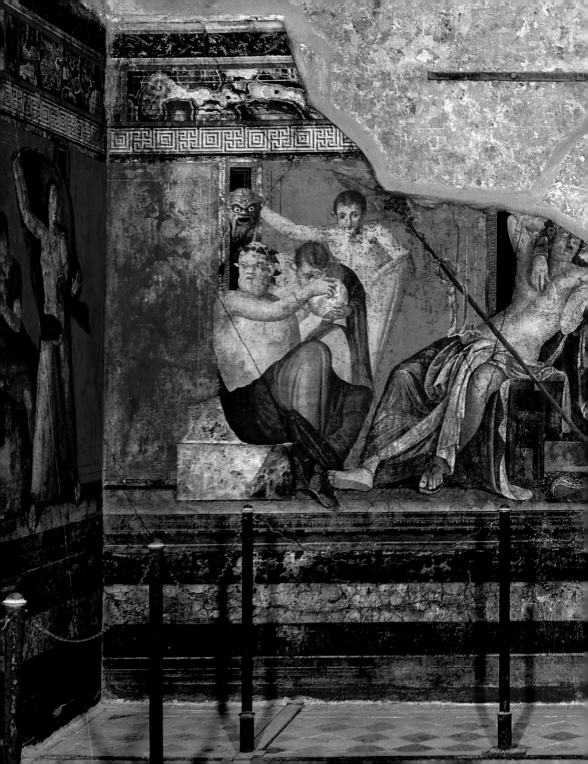

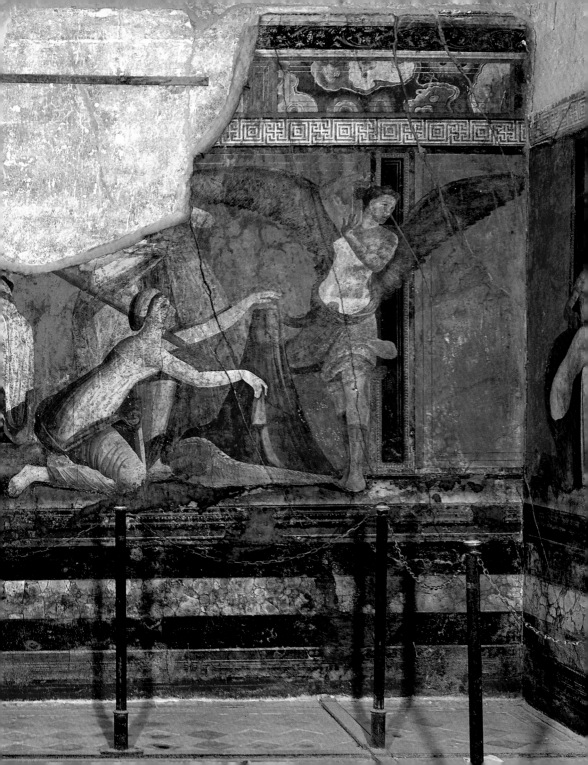

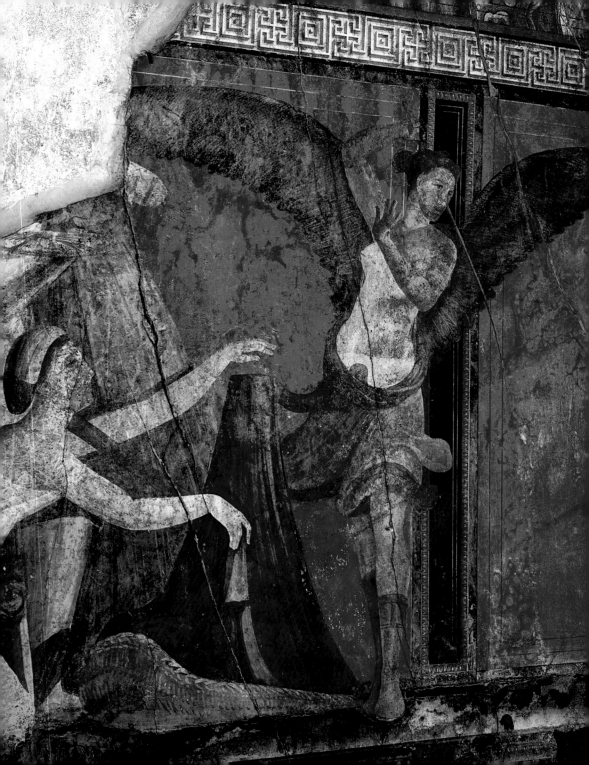

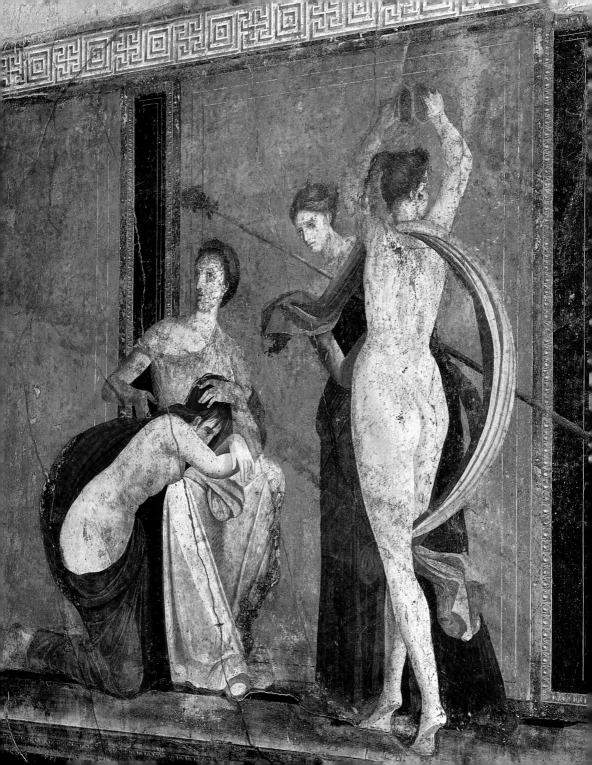

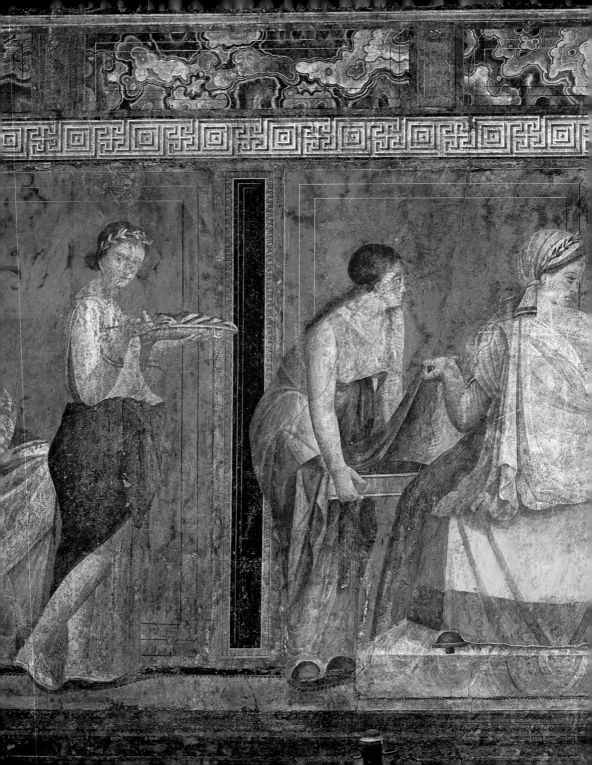

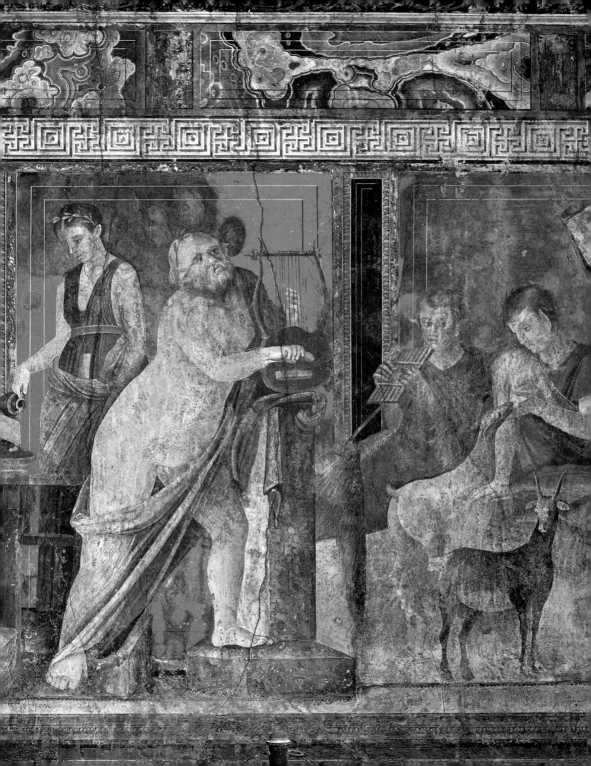

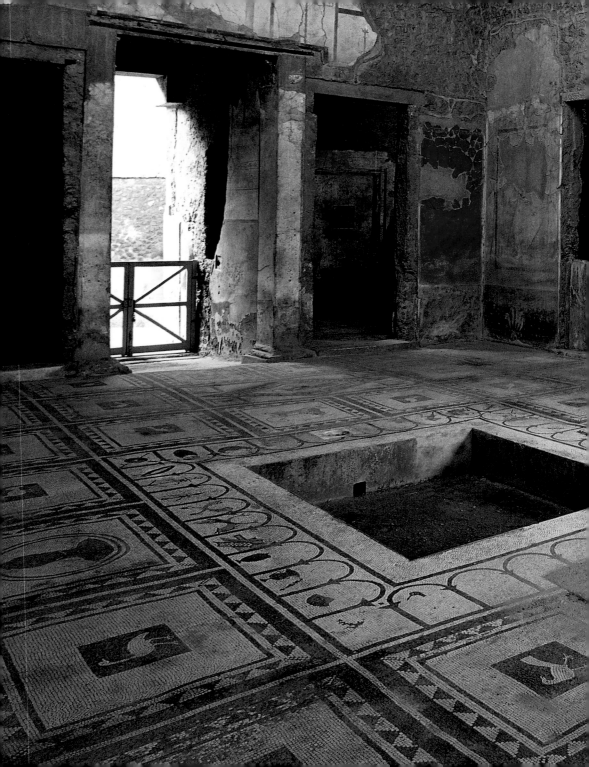

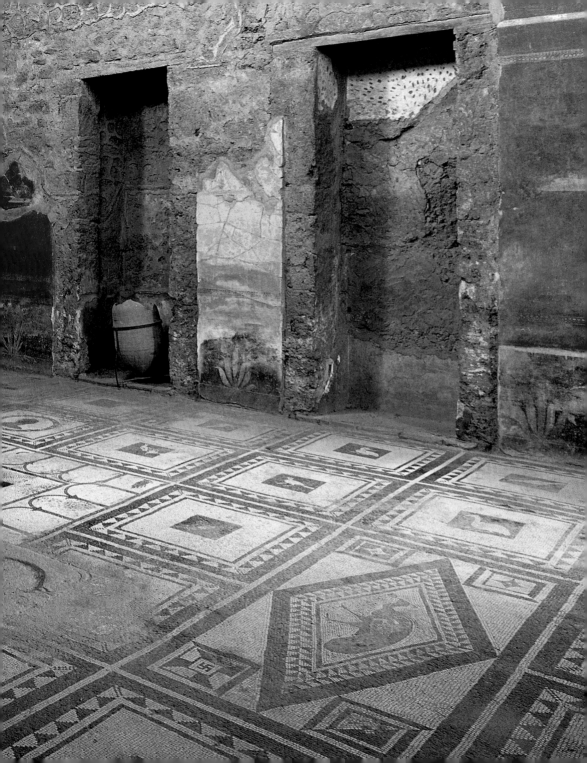

35. House of the Vettii,
vestibule with double entrance
and fresco of *Priapus*.

Following pages
36. House of the Vettii, red reception
room with fresco depicting *Cupids
and Pysches at Work*.

protection expressed in the symbolic rep-
resentations of snakes to be seen in kitch-
ens. In other cases, we find realistic scenes
of the lives and duties of the inhabitants.
This communicative function can also be
performed by the floor decoration, as ex-
emplified by the large mosaic in the atrium
of the House of Paquius Proculus (no. 42)
looking onto the central thoroughfare of
Via dell'Abbondanza (fig. 34). After the
entrance with the representation of a large
chained dog keeping perpetual watch over
the safety of the household, the entire floor
was covered with a black and white mosaic
imitating the coffered ceiling with coloured
scenes inside the panels: some bounded by
a frame of juxtaposed triangles containing
birds of different species; a lion and a pea-
cock inside a lozenge; and two isolated pan-
els in the centre of the long sides, where two
summary portraits of a male and a female
figure were also found. The client and the
mosaicist appear to have been possessed
by a sort of *horror vacui*, as even the edge
of the *impluvium* was totally covered in

decorations inside arched frames: scenes of
combat and weapons, cornucopias, anchors
and amphorae, a quiver of arrows, a club, a
caduceus, the palm of victory, a goat, fish,
and a bust of a young person. Apart from
the latter, which is so characterized as to be
considered a portrait (and all the more sig-
nificant given its location in the atrium), all
this complex decoration appears, however,
to go no further than a general presenta-
tion of subjects connected with wealth and
prosperity. The visitor's perceptions were
therefore stimulated by different mental
associations. The birds suggested the idea
of being in an *aviarium* or aviary, some-
thing only the most sumptuous suburban
residences could afford. The lion and the
combat alluded to activities regarded as en-
nobling, like hunting and war, the goat to
the bucolic world, the two busts, caduceus
and club to the religious sphere, and an-
chors, cornucopias and amphorae to trade
and the affluence to be derived from the
skilful practice of a profession.

The most complex and coherent decora-

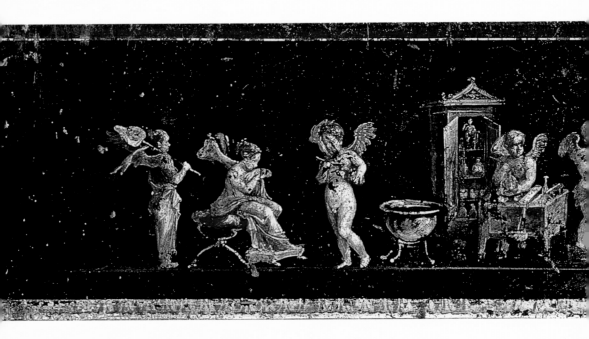

tive cycle is, however, unquestionably the one in the House of the Vettii (no. 20). This belonged at the time of the eruption to the rich brothers A. Vettius Restitutus and A. Vettius Conviva, who were probably responsible for having it renovated around 70 AD and redecorated with depictions chosen one by one for all the rooms. Analysis of the entire sequence of images in the house does indeed suggest precise connections between the functions of the individual spaces and the choice of subject matter for their decorations. The entrance was thus under the surveillance and protec-

tion of an ithyphallic Priapus guaranteeing prosperity (fig. 35). The *triclinium* looking onto the left side of the atrium – with Jove, Leda and Danae in the upper section and panels showing the metamorphosis of Cyparissus and the fight between Eros and Pan – conjured up the anxiety, joy and transfiguration of the experience of love. The same theme reappeared in more summary form also in the decoration of a *cubiculum*, with depictions of Leander swimming towards his beloved Hero and Ariadne awakened by a cupid. Figures of children performing sacrifices to the penates in the atrium re-

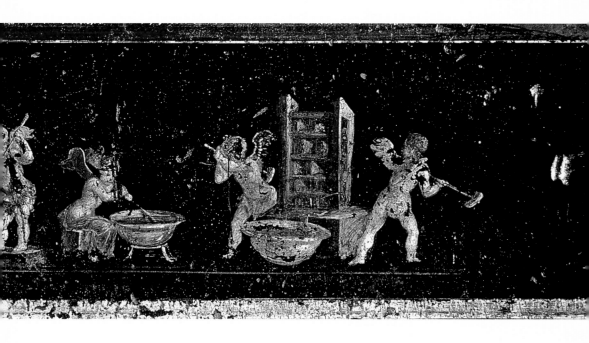

called the cult of ancestors, and a scene of cupids sacrificing to Fortuna was suitably located by the large *arca* or chest of bronze where the riches of the house were kept. Figures apparently serving to fill up gaps can also be seen as fragments of a mosaic to be pieced together on completion of a tour of the entire house. The long frieze in the atrium of cupids with various land animals and sea creatures constituted a sort of introduction to the more important and sophisticated frieze in the *oecus*, the best-known part of the house, where ethereal psyches assisted the young servants

of Venus in all the major activities of the time: serving wine and cleaning garments, growing flowers and producing perfumes, the work of the goldsmith and the blacksmith (fig. 36). Among the figures in the large black panels of the peristyle, a generic depiction of a poet and Urania, the muse of astronomy, alluded to the intellectual activities of the masters of the house, a simplified treatment of a theme handled with far more complexity in other Pompeian cycles. The subjects depicted in the *triclinium* looking onto a small, secluded peristyle instead spoke the languages of

eroticism, with a painting of Auge surprised by the drunken Hercules, and of otherness, with the scene of Achilles disguised as a girl but identified by Ulysses. The subjects of the paintings in the service areas were also in line with their functions, with a niche of masonry with representations of the Lares and the *genius loci* protectively located in the vicinity of the hearth. One small bedroom, identified for no reason as the quarters of the cook, was instead decorated with pornographic paintings suggesting a domestic brothel, a perfect introduction to the profession practiced by the slave Eutychis, whose name and price (just two *assi*) were scratched on a wall in the entranceway.

Finally, images predominated over everything else in the two exedras symmetrically adjoining the peristyle, conventionally referred to as picture galleries precisely by virtue of the quality of the artwork. The one situated on the left of the passageway between the atrium and the peristyle presented a painting of the infant Hercules strangling snakes and, on the opposite wall, Dirce being bound to the horns of a bull by Amphion and Zethus, whose mother she had kept in slavery for years, against a yellow background with architectural views in the side panels. The main wall facing the entrance instead presented the epilogue of the Dionysian revelation, a gory scene of the slaying of Pentheus by the maenads (fig. 37). The walls of the symmetrical picture gallery, adorned at the sides and in the upper section with heavy architectural settings, again presented large paintings in the central areas. The left wall showed Daedalus delivering the wooden cow to Pasiphae, the prelude to the unnatural coupling out of which the Minotaur was born. On the central wall, beneath the depiction of a seated divinity holding a cornucopia in the upper section (Concordia?), Ixion of Thessaly, the impious king guilty of an attempt on the virtue of Juno, is bound to a wheel in the presence of Mercury, Juno, Vulcan and Iris. The female figure shown in an attitude of supplication may be Nephele, the cloud sent

Following pages
37. House of the Vettii, south picture gallery, paintings with *Hercules Strangling the Serpents* and the *Punishment of Pentheus*.
38. House of the Vettii, south picture gallery, paintings with *Daedalus Presents the Wooden Cow to Pasiphaë*, *Sacrifice of Ixion* and *Dionysus Discovers Ariadne Asleep*.

by Jove to trick Ixion, thus engendering the race of centaurs. The painting on the south wall introduces the blissful union of a god and a mortal, again Dionysius and Ariadne, shown in the moment when he discovers the Cretan princess asleep on a tiger skin (the symbol of the boundaries of the world reached by the festive Bacchic procession), with Theseus's ship sailing away from the coast of Naxos in the background (fig. 38). Like the *megalographia* in the Villa of the Mysteries, the paintings in the two exedras have given rise to a whole variety of interpretations. The underlying theme in the first appears to have been the discovery or revelation of predestination for great deeds: in childhood for Hercules, in adolescence for the Theban twins, and in maturity for Dionysius, finally acknowledged as a god in Greece after the slaying of Pentheus. The fact that the Vettius brothers belonged to the priestly order of Augustales, responsible for the rites of the imperial cult, may have inspired this thematic unity, as predestination for honours and power was a key tenet of imperial ideology between the reigns of Nero – whose birth at sunrise was recalled as an omen of future glory – and Vespasian, whose rise to the throne was heralded by numerous portents and even by extraordinary thaumaturgical powers. It may be possible to detect signs of the brothers' involvement in the new course taken by the empire under the Flavian dynasty in the choice of the mythological episodes depicted in the second. The figure probably to be identified as Concordia facing the entrance appears to allude to a new age of peace and prosperity after the misuse of power that engendered a monster like Nero, comparable to semi-human creatures like the centaurs and the still more horrifying Minotaur. The end to the horror could only be marked by the last episode of the Cretan cycle, where the meeting of Dionysius and Ariadne emphasized the attainment of perfect harmony between human beings and divinities, as suggested earlier still in the main hall of the Villa of the Mysteries.

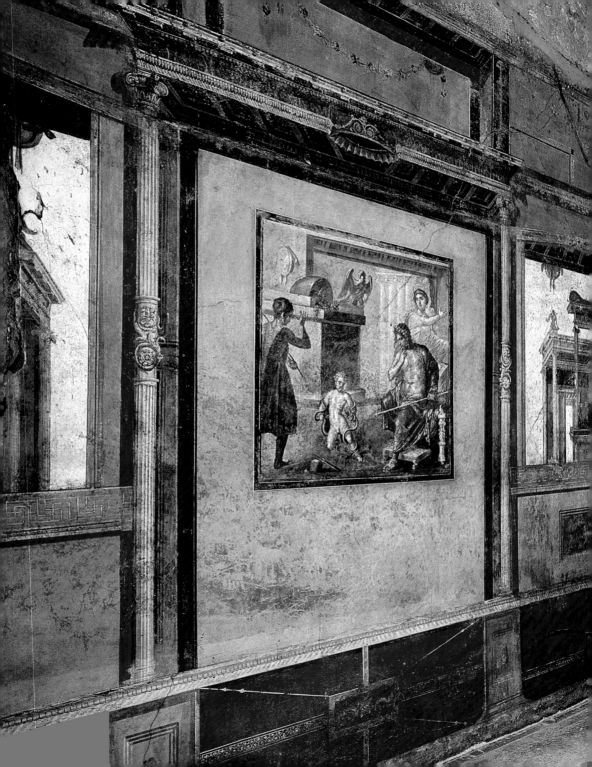

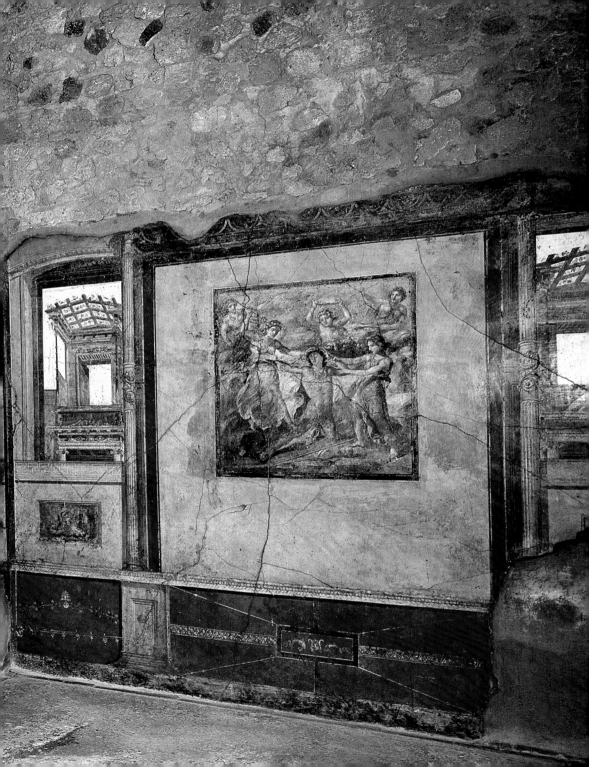

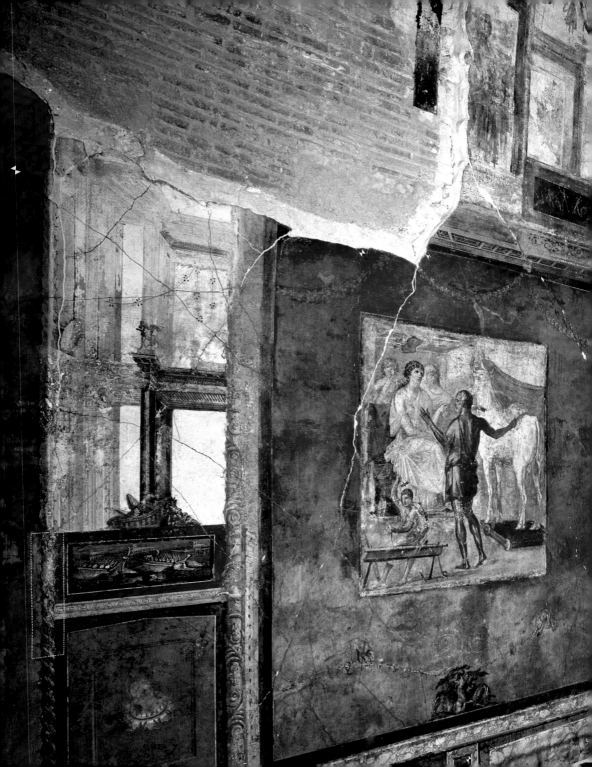

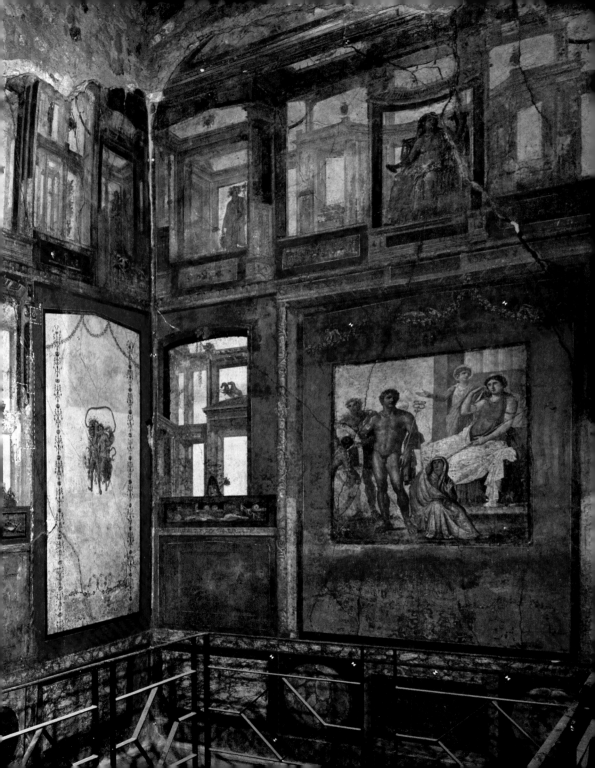

EPILOGUE
THE ROMAN HOUSE AFTER POMPEII

The end is known. Nine days before the calends of an unspecified month in 79 AD, Pompeii and Herculaneum were destroyed in just a few hours by the eruption of Vesuvius. Everything was preserved for centuries just as it had been in that precise instant beneath a thick layer of ash and lapilli until the first chance discoveries and the extensive excavations commenced in 1748. It was above all the houses that struck the discoverers at first and, as this brief outline also shows, the Vesuvian town has been used ever since as the greatest source for our understanding of ancient private building. Something has altered in this perception, however, with the gradual growth of our information and the unearthing of residential areas on many other archaeological sites. It is above all consideration of Ostia, another important, well-preserved and extensively

excavated town, that suggests some anomalies. We know that the great port of Rome underwent radical urban renovation a few decades after the destruction of Pompeii and that many of its public and private buildings were then buried beneath a layer of in-fill about one metre thick, something similar to what had happened in Pompeii during the 2nd century BC, albeit on a far larger scale. As we walk through the splendid site of Ostia, however, what we have learned so far about the Roman house seems practically useless. Only two houses in all the city have preserved the canonical layout with Tuscan atrium that was so common in Pompeii. We find instead luxurious residences with peristyle courtyards, orderly houses bounded by large green areas, modest two-family houses laid out in rows, and *insulae* or tenement blocks containing shops, workshops, places

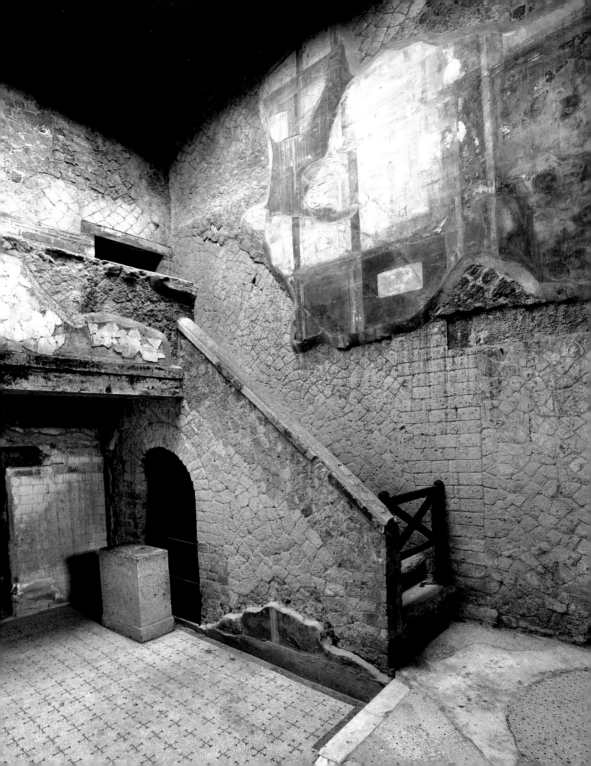

of worship and dozens of homes (fig. 39). A city very different from Pompeii, inspired by the new face of Rome after the fire of 64 AD under Nero, and now retaining practically nothing of the ancient colony of the republican era. What happened in the space of just a few years? Is it possible that the unquestionably radical urban renovation of Ostia turned a consolidated way of life completely upside-down and that the world therefore changed so drastically after 79 AD? In actual fact, radical change was already underway at the time of the destruction of Pompeii. In order to understand the timing and forms of this phenomenon, all we have to do is travel a few kilometres to nearby Herculaneum, which shared the fate of Pompeii, as we know. Here too, as in Ostia, we realize that what we have learned from the Pompeian houses is no longer so useful. We do come across some large houses with atrium and peristyle here and there (the Samnite House and the houses of the Wooden Partition, the Tuscan Colonnade, the Black Room and the Bicentennial) and we do recognize some small houses with covered atrium of the ancient type (House of the Fullonica). We are, however, surrounded above all by large, multi-storey tenement buildings (the *Insula Orientalis*), by large urban villas that are far more spacious than those of Pompeii (the houses of the Deer, the Relief of Telephus, the Mosaic Atrium, the Inn and Aristides), and by a large number of buildings that have almost nothing in common with the atrium house. One example of many is the House of the Beautiful Courtyard (fig. 40), where we find a broad, deep vestibule providing access to a small courtyard decorated with a sophisticated mosaic. From there, a staircase leads on one side to the apartment on the upper floor and on the other to an immense hall taking up nearly half the entire surface of the ground floor. It is almost like walking into a medieval house rather than one built at the time of the last renovation of the House of the Vettii (no. 20). One possible explanation of this change is perhaps to be found in the emphasis on large halls, like the one in the House of the Beautiful Courtyard, which are present in nearly all the houses of Herculaneum. In the

Alle pagine seguenti
40. Herculaneum, House
of the Beautiful Courtyard.

rebuilding carried out after the earthquake in this town on the coast, which enjoyed a high standard of living but lacked the social and political dynamism of Pompeii, it was decided to focus on spaces for banqueting, as it was such occasions that provided the opportunity to meet and talk and also to take decisions that could affect the small community. On closer consideration, we see that this is the world of Trimalchio as described in the *Satyricon* by Petronius in that very period, where the economic activities, social life and entertainments of the master of the house and his numerous guests are shown in the setting of the famous banquet. Finally, the few traditional houses in Herculaneum all have one thing in common: they are the oldest to be found there, all built in the second half of the 2nd century BC and the first half of the 1st.

Was Pompeii therefore unwilling or unable to renew itself like Herculaneum between the early Imperial age and the years following the destruction caused by the earthquake? There probably were changes after that date, but none with any significant impact inside the city walls, as the work was confined into dividing old atrium houses up into lodgings to let. Attention has been drawn here, however, to archaeological discoveries in small towns situated between the mouth of the Sarno river and the sea revealing the presence of "large tenements with shops and taverns (*cauponae*) on the ground floor and internal staircases and large balconies providing access to the apartments on the upper floors". The same words could also be used to describe a district of Ostia. The innovations therefore took place not in Pompeii but elsewhere, in new or renovated settlements where life was lived at a quicker pace in the period of reconstruction, so much so that the Sulpicii, a great merchant family from Pozzuoli, decided to move their business to present-day Moregine, where they bought the Building of the Triclinium.

Pompeii was instead weighed down by the past. Its political life and the social conventions of its ruling class still influenced the behaviour of citizens. It was an old city, and one that was about to become eternal.

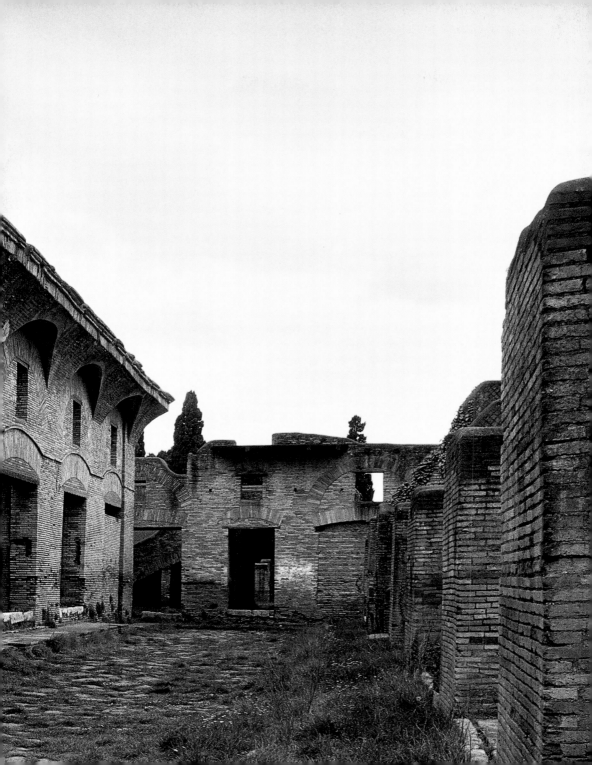

GLOSSARY

ALA
Wing of a Roman house opening completely onto the atrium.

ATRIUM
Central area of the Roman house, often with an *impluvium* in the middle of the floor to collect rainwater. The types listed by the architect Vitruvius are Tuscan, displuviate, testudinate, testrastyle and Corinthian, the latter with four or more columns alongside the *impluvium*.

COMPLUVIUM
Opening in the roof with sloping sides over the atrium to provide the house with light and air. The *impluvium* was located beneath to collect rainwater.

CUBICULUM
Bedroom. *Cubicula* were dark, secluded chambers located on the long sides of the atrium. In wealthy houses, they were generally used by just one person with an attendant servant or maid. They were also located in the area of the peristyle from the 1st century BC on.

HORTUS
Area situated to the rear of the atrium and used to grow produce for everyday consumption. This vegetable garden underwent transformation in the 2nd century BC to include *viridaria* and peristyles, and the term was then used to indicate the large private parks on the immediate outskirts of cities.

IMPLUVIUM
A basin in the atrium of a Roman house to collect rainwater from the roof. Often connected to a cistern.

INSULA
A block bounded by streets and occupied by one or more houses. Entrances in the façade provided access to the houses, the shops and the staircases to the upper floors.

LARARIUM
Altar or shrine of the lares, the guardian spirits of the home and the family living there.

OECUS
Banqueting hall, larger than the *triclinium* and capable of accommodating dozens of guests and performances by entertainers (jugglers, dancers and actors). The name is of Greek origin and corresponds to the Latin *cenatio*.

PERISTYLE
Courtyard with columned porticos located in the rear section of a Roman house.

PRAEDIUM
Property situated inside or outside a city. A Pompeian inscription provides proof that the term could also be used for a

huge urban property comprising a small park, a garden and various buildings (the *Praedia* of Julia Felix).

SACRARIUM

Chamber with an altar for domestic worship. It could also contain religious statues and other objects held sacred by the master of the house.

TABLINUM

Part a Roman house used as a living room or to receive visitors and guests. Used also to store family records in the homes of the aristocracy.

TRICLINIUM

Dining room with three couches, each accommodating three diners, arranged along the walls.

VIRIDARIUM

Garden with ornamental plants and flowers located in the middle of the peristyle. Gardening became fashionable in the 1st century BC amongst wealthy Romans and specialized gardeners (*topiarii*) were hired to take care of the *viridarium*.

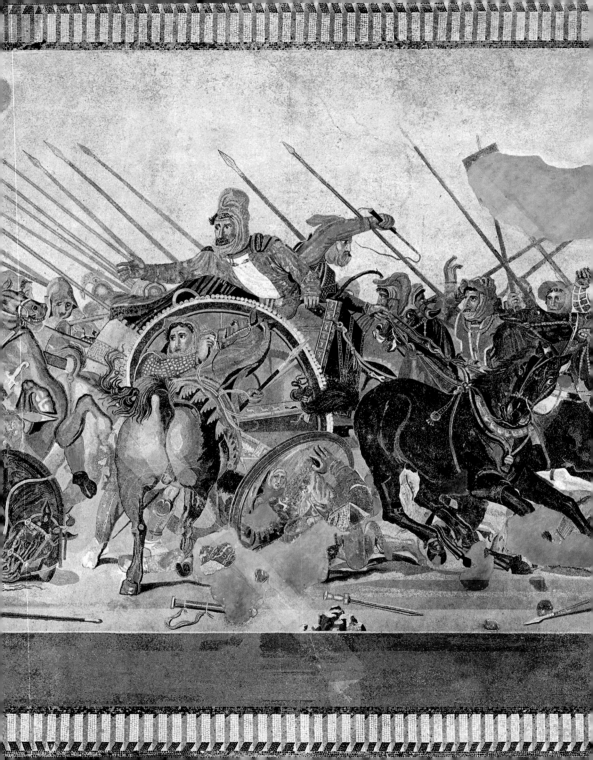

Date	Historical events	Historical events
753 BC	Founding of the city. Ruled by kings, a total of seven according to tradition, until 510 BC	
c.750–725 BC		Founding of the *emporion* of Pithecusae. Founding of the Euboic colony of Cumae
Late 7th – early 6th century BC		Founding of the city
578–534 BC	Reign of Servius Tullius	
534–510 BC	Reign of Tarquinius Superbus	Supremacy of Cumae in the Bay of Naples
509 BC	Expulsion of the Tarquin family and birth of the Roman Republic	
504–484 BC		Tyranny of Aristodemus of Cumae
c.500 BC	Secession of the Plebs to the Aventine Hill. Start of conflict between the patrician and plebeian orders	
First half of the 5th century BC	Supremacy of the Volsci in southern Latium	
438 BC		Formation of the populus Campanus
423–421 BC		Conquest of Capua and Cumae by the Campanians
Second half of 5th – end of 4th century BC		Samnites in Pompeii
387 BC	Sack of Rome by Gauls under Brennus	
343–338 BC	1st Samnite War (343–341 BC)	Capua and Cumae obtain Roman citizenship with no voting rights (*civitas sine suffragio*) between 341 and 338
326–304 BC	2nd Samnite War. Founding of Roman and Latin colonies Latium and Campania	
310 BC		Landing of the Roman fleet under P. Cornelius and devastation of the countryside around Pompeii and Nuceria. The marauding troops are chased back to their ships by peasants and suffer heavy losses
308 BC		Defeat of Nuceria. Pompeii enters the Roman sphere as an allied city (*civitas foederata*)
299–290 BC	3rd Samnite War. Rome controls most of central-southern Italy, where new colonies are established	

House of the Faun, mosaic depicting
the *Battle of Issus*, detail.

Date	Historical events	Historical events
264–242 BC	1st Punic War, at the end of which Sicily becomes a Roman province	
218–202 BC	2nd Punic War	Destruction of Nuceria by the Carthaginians
211–205; 200–197 BC	1st and 2nd Macedonian wars	
171–168 BC	3rd Macedonian War	
149–146 BC	3rd Punic War and conflict with the Aechean League. Destruction of Carthage by Scipio Aemilianus and of Corinth by Lucius Mummius	Dedication of the *donarium* of Lucius Mummius in the Sanctuary of Apollo (146 BC)
123–121 BC	Gaius Gracchus seeks to impose the agrarian reform drawn up by his brother Tiberius. The proposal is rejected and Gaius commits suicide	
Second half – end of the 2nd century BC		Flourishing of Pompeii. Pompeian merchants arrive in the major ports of the Mediterranean
102 BC	Marius defeats the Cimbrians and Teutons and becomes the leading figure in the political life of Rome, serving as consul seven times	
91–89 BC	Social War against the allies of Rome. Aristocratic party led by L. Cornelius Sulla	City besieged by Sulla. Inscriptions of the *eítuns* series
89 BC	Granting of Roman citizenship to ther allied cities	*Municipium* of Pompeii (?)
90–70 BC	Civil war between Marius and Sulla. Sulla becomes dictator (82). Death of Sulla at Cumae (78). Servile War against Spartacus (73–71). Pompey and Crassus consuls (70). Trial of Gaius Verres for embezzlement and theft of works of art in Sicily	Pompeii sides with Marius (?)
80 BC		Colony of veterans established by P. Cornelius Sulla, nephew of the dictator. Latin becomes the official language
70 BC		First census held by the *duoviri quinquennales*
60 BC	1st Triumvirate (Pompey, Crassus and Julius Caesar)	
58–51 BC	Julius Caesar fights and wins in Gaul. Campaign of Crassus against the Parthiand (55–53). His defeat and death at *Carrhae*	
49–48 BC	War between Caesar and Pompey. Victory of Caesar at Pharsalus and death of Pompey	14 May 49. The former consul Cicero is offered the command of the troops stationed in Pompei but refuses and embarks for Greece

Date	Historical events	Historical events
46 BC	Inauguration of Caesar's Forum	
45–44 BC	Caesar is proclaimed dictator for life and then assassinated on 15 March 44 in the Curia of Pompey	
43–42 BC	2nd Triumvirate (Octavian, Antony and Lepidus). Defeat of Caesar's assassins at Philippi. Assassination of Cicero	
40–31 BC	War between Antony and Octavian. Defeat of Antony at Actium and his death together with Cleopatra in Alexandria	
27 BC	Octavian (*Divi filius*) is awarded the honorific Augustus	
14 AD	Death of Augustus. Tiberius is proclaimed emperor (14–37)	
Ages of Augustus and Tiberius		End of the leading families of the first colonial period. Birth of a local elite connected with the imperial family
37–41, 41–54	Reigns of Caligula and Claudius	
54–68	Reign of Nero	
58		Fighting between Nucerians and Pompeians in the Amphitheatre. Games banned in the city for 15 years by the Roman Senate
February 62/63		Earthquake strikes Pompeii, Herculaneum and others towns in Campania
63 (?)		Visit of Nero and Poppea
64	Fire in Rome	
68	Death of Nero and end of the Julian-Claudian dynasty. Vespasian is proclaimed emperor after a bloody civil war (69), initiating the Flavian dynasty	
70	Conquest of Jerusalem by Titus	
79, June	Death of Vespasian. Titus is proclaimed emperor (79–81)	
79		Destruction of the Vesuvian cities (Pompeii, Herculaneum, Stabiae and Oplontis) in the volcanic eruption
80	Fire in Rome	

PHOTO CREDITS

Printed in Italy
by 24 ORE Cultura, Pero (Milan)
June 2013